IMAGES
of America

WASHINGTON COUNTY
IN THE CIVIL WAR

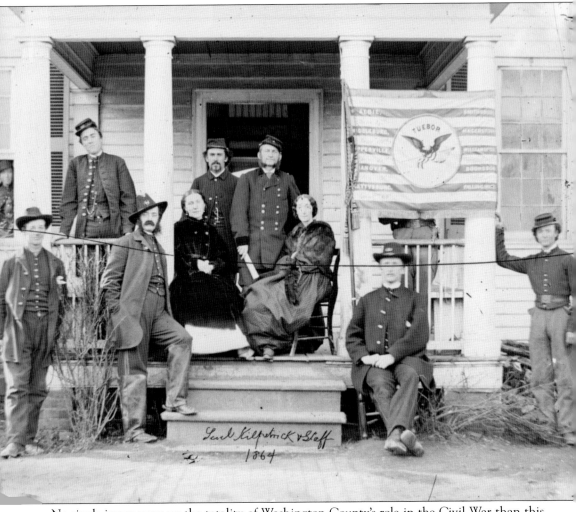

No single image sums up the totality of Washington County's role in the Civil War than this photograph of Brig. Gen. Hugh Judson Kilpatrick and his staff at Stevensburg, Culpeper County, Virginia, in March 1864. The battle honors painted on the stripes of his headquarters' flag, which include places like Hagerstown, Smithsburg, and Williamsport, read like a gazetteer of Washington County geography. They were earned during the pursuit of the Army of Northern Virginia following its defeat at Gettysburg nine months earlier. (Library of Congress.)

ON THE COVER: Brig. Gen. John Caldwell (standing at center) and his staff were photographed in camp in the weeks after the Battle of Antietam. In the wake of the bloodiest single-day battle of the war, the Pleasant Valley area hosted the Army of the Potomac as it recovered and dealt with the carnage-strewn landscape. Caldwell temporarily assumed command of the 1st Division, Second Corps in the advance on the Sunken Road ("Bloody Lane") after Maj. Gen. Israel Richardson was mortally wounded. (Library of Congress.)

IMAGES
of America

WASHINGTON COUNTY
IN THE CIVIL WAR

Stephen R. Bockmiller

ARCADIA
PUBLISHING

Published by Arcadia Publishing
Charleston, South Carolina

Printed in the United States of America

Library of Congress Control Number: 2015942249

For all general information, please contact Arcadia Publishing:
Telephone 843-853-2070
Fax 843-853-0044
E-mail sales@arcadiapublishing.com
For customer service and orders:
Toll-Free 1-888-313-2665

Visit us on the Internet at www.arcadiapublishing.com

*Dedicated to the memory of Washington County's most unheralded
serviceman, George Leonard Fisher (1846–1927):
enlisted at age 15 as a private, Company A, 7th Maryland Volunteers
(1862–1865); prisoner of war (1864–1865); private through first
sergeant, Company A, 2nd US Infantry (1866–1879);
occupation of the South and Ute Indian campaigns; sergeant through
captain, Maryland National Guard (1880–1898); captain, Company
B, 1st Maryland Volunteers (1898–1899); Spanish-American War;
captain, Maryland National Guard (1899–1911), Retired; drill
instructor, Maryland Home Guard (1917–1918); last Civil War veteran
to serve as superintendent of Antietam National Cemetery (1927)*

CONTENTS

ACKNOWLEDGMENTS

First and foremost, there are two people, who more than any others deserve credit here. Those two people are my wife, Stefania, and my daughter, Sarah. Completing a project of this magnitude is time consuming, and my efforts dented time I should have been spending with them. I thank them for their love, their support, and most of all, their patience and tolerance of my projects.

Thanks must also be extended to my friend and fellow Arcadia author Lawrence J. Bopp and to Kathleen A. Maher, my supervisor in the Hagerstown Planning and Code Administration Department. They are always supportive and encourage my efforts.

All images are credited to their owners or repositories. Those images that appear without a credit line are in the collections of the Library of Congress.

Many people deserve my thanks for their help. Stephen Recker, the leading expert on postwar photography at Antietam, has been especially helpful, providing several images that you will see. The Western Maryland Room of the Washington County Free Library (John C. Frye, director) and the Washington County Historical Society (Linda Irvin-Craig, director) are incredible repositories of images that have been indispensable in creating this work. Several descendants of local citizens and soldiers as well as descendants of soldiers from elsewhere who fought here graciously shared with me images of their ancestors, many of which are published for the first time in this book. Local image collectors Kevin Boyer, D. Jeffrey Brown, and Justin Mayhue were especially generous in sharing photographs from their collections.

Douglas Bast of the Boonesborough Museum of History and fellow Arcadia authors Tim Doyle and David Finney were especially accommodating to my requests to share images from their projects and collections. Several libraries, historical societies, and museums from New York to Illinois to Georgia allowed me to use images from their collections to improve this story, and I am grateful for their help. Dennis Frye of Harpers Ferry National Historical Park, Ted Alexander of Antietam National Battlefield, and Bob Ambrose of Fort Frederick State Park allowed me to "pick their brains" for historical information and details that appear in the picture narratives. I also thank prominent Antietam historian Thomas G. Clemens, who reviewed my draft and provided valuable comments and guidance.

I especially thank Emory A. Cantey Jr., who provided the very rare daguerreotype image of Thomas H. Quantrill that appears on page 11. He has an outstanding collection of Quantrill- and Missouri-related images, which can be viewed on the Internet. As of the publication of this book, the website's URL is www.canteymyerscollection.com.

INTRODUCTION

In March 1864, Gen. Hugh Judson Kilpatrick stood on the porch of his headquarters near Stevensville, Virginia. He was having his photograph made while surrounded by friends and staff officers and a flag. Emblazoned on each stripe of that banner was the name of some far-off, obscure location and the date on which his men fought at that place.

As I worked on this project, this image was always in the back of my mind. The places that were painted onto those stripes were towns of which many had never heard. Smithsburg, Boonsboro, Falling Waters, and the other locations emblazoned on that flag meant little to most Americans. But it was a testimony to four years of sacrifice, suffering, and deprivation visited upon Washington County by the Civil War. From the arrival of "Isaac Smith, Prospector" in the summer of 1859, through the creation of one of the nation's first Civil War veterans' organizations in late 1865, Washington County was transformed in many ways, and at the same time influenced the progress and outcome of the war.

Washington County held a unique geographic location in history. Maryland was a slaveholding border state of divided loyalties that did not withdraw from the Union. The county was separated from slaveholding Confederate Virginia by only the historic Potomac River. Its separation from the free soil of Pennsylvania was the equally historic and even narrower Mason-Dixon Line. At its narrowest, Washington County separated Virginia and Pennsylvania by less than two miles.

By the end of the war, scores of Washington Countians had made the supreme sacrifice on behalf of the blue or the gray. From artist John Stemple, who was killed on a rooftop by a stray bullet as he sketched the Battle of Hagerstown as it raged in the streets below, to telegraph operator Edward Aughinbaugh, who was detained by John Brown's raiders at the Mountain House following their aborted raid, hundreds of private dramas played out in our community during this time. War touched the lives of everyone. Especially impacted was the local African American population. Some free, some enslaved, the war brought to their lives a nearby attempt at a slave revolt, their first recruitment into the US Army, and, ultimately, the abolition of slavery in late 1864. As the populace emerged from four years of carnage, it found a nation, a state, and a county forever changed.

As readers progress through this book, they will meet two families around which I tried to weave this narrative. One family, the MacGills, were vehemently pro-South, with a father and four of five sons in the Confederate service and the ladies doing what they could to help "the cause." The other family, the Mobleys were equally pro-North and supported the preservation of the Union. But the community was far more than just these two families.

Over the last 155 years, Washington County has been forever altered by the war and its aftermath. Antietam was the bloodiest single-day battle of the Civil War and the site is now a national park. Likewise, the war, directly or indirectly, impacted locations in the county that are also now units of the National Park Service—Harpers Ferry and the Chesapeake & Ohio Canal. Fort Frederick State Park and South Mountain State Battlefield are among the state's contributions

to commemorating the war. National and Maryland military cemeteries in Sharpsburg and Hagerstown host the mortal remains of thousands of soldiers who "gave the last full measure." Others still lie where they fell during the war.

Anniversaries observed in 25-year intervals from 1912 to 2012 reminded the nation of the sacrifice here. The monuments erected by the soldiers and their descendants, the markers installed around the county by the US Department of War, and more contemporary efforts to install "wayside exhibits" to highlight the unsung stories of these men provide ample opportunity for the visitor to learn about what happened here. Civil War tourism has become a significant part of the Washington County economy.

It is those more obscure stories that this book attempts to focus on. Here, you will not find the well-known photographs of wrecked artillery in front of the Dunker Church. Bodies lying in heaps along the Hagerstown Road will not be seen here. While they are important to the greater story, this work focuses on the lesser-known personalities and stories associated with the county's Civil War drama.

The author hopes that this book serves as more than just a history book. My desire is that it also serves as an invitation for the reader to come to Washington County. Marvel at the commanding heights above Burnside's Bridge—Georgians' Overlook—where a few men held off legions of attackers. Stand at Penmar Park and gaze across the Cumberland Valley, viewing much of the area over which the retreat from Gettysburg was fought. Explore the remnants of a canal that was a lifeline to the besieged national capital, and the modest farmhouse where a race's march toward freedom shifted into overdrive. Washington County has one of the highest concentrations of important Civil War resources in the nation.

While it seems distant to us now, the march of time will bring the bicentennial of the Civil War to our calendars faster than we are willing to admit. While it is perceived by many as "ancient history," the Civil War is recent history. We live in a world where children of Civil War veterans still live among us—150 years is a mere blip in the course of time. When our children and grandchildren observe the bicentennial of Antietam in 2062, we must be able to say we preserved this legacy and handed it down to them. We must be good stewards of the natural and historical treasures that our community has been entrusted with and keep the memory of these men and women, blue and gray, alive and their stories known for future generations.

One

THE COMING STORM

ANTEBELLUM WASHINGTON COUNTY TO 1861

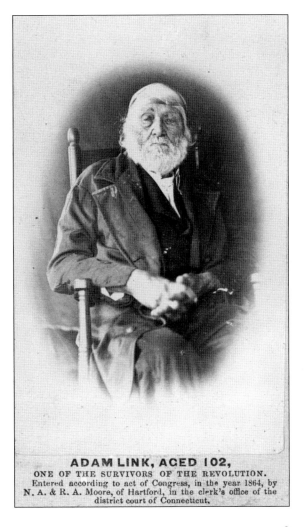

ADAM LINK, AGED 102,
ONE OF THE SURVIVORS OF THE REVOLUTION.
Entered according to act of Congress, in the year 1864, by
N. A. & R. A. Moore, of Hartford, in the clerk's office of the
district court of Connecticut.

To understand the citizen of 1861, look to the nation's founding less than a century earlier. Many people had fathers and grandfathers who served in the Revolution, and a tiny number of those patriots survived in 1861. Hagerstown-area native Adam Link was born in 1761. He enlisted in the Continental army in 1777 and served on the frontier. He moved to Crawford County, Ohio, after the war and was 102 years old when he passed away in 1864.

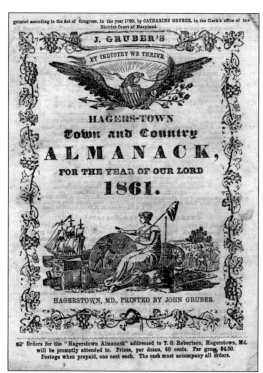

J. GRUBER'S

BY INDUSTRY WE THRIVE

HAGERS-TOWN

Town and Country

ALMANACK,

FOR THE YEAR OF OUR LORD

1861.

HAGERSTOWN, MD., PRINTED BY JOHN GRUBER.

Orders for the "Hagerstown Almanack" addressed to T. G. Robertson, Hagerstown, Md. will be promptly attended to. Prices, per dozen, 40 cents. Per gross, $4.50. Postage when prepaid, one cent each. The cash must accompany all orders.

In 1797, John Gruber began printing an almanac from his printing shop on South Potomac Street in Hagerstown. Although he passed in the 1850s, the almanac continued to be printed by his family. Amazingly, *Gruber's Hagers-town Town and Country Almanack* is still in print 218 years later, and the business is still owned by his descendants. Its cover looks little different from this issue printed for the year 1861. (Chad Fisher.)

In October 1814, John Gruber published *The National Songster*. A collection of patriotic songs, this work contains the poem "The Defense of Fort McHenry," with the note "Tune: To Anachreon in Heaven." The poet was Francis Scott Key. Published within two months of the Battle of Baltimore, this was the first time the lyrics of "The Star-Spangled Banner" appeared in a songbook. This drawing of Gruber's shop was published in 1906. (Author's collection.)

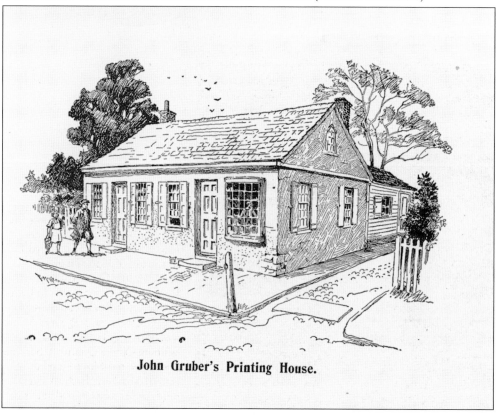

John Gruber's Printing House.

Washington County takes great pride in its German heritage. It is evident in the culture and architecture of the area. This Civil War–era image depicts Robert Brent Keyser and his cousin Anita Hunt, the great-great-grandchildren of Hagerstown founder Jonathan Hager. According to family tradition, Robert is shown wearing Jonathan's silk waistcoat nearly a century after the founder's passing in 1775. (City of Hagerstown.)

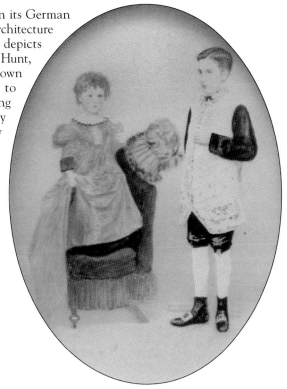

Thomas Henry Quantrill was the son of a War of 1812 hero and Hagerstown moderator (mayor). In the fall of 1836, Thomas and Caroline Quantrill left Hagerstown for a new life in Canal Dover, Ohio, at the same time Caroline became pregnant. A son was born in July 1837. That son, William Clarke Quantrill, became one of the most loved (and most feared) Missouri "bushwhackers" produced by the Confederate side in the war. (Emory A. Cantey Jr.)

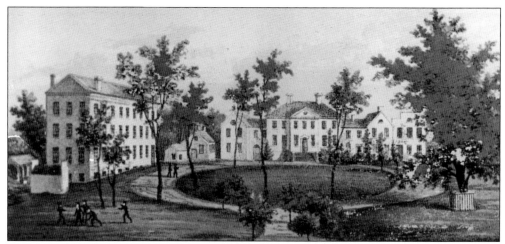

One of the finest boys' schools in the country, the College of St. James was popular with prominent families, North and South. St. James graduates served as officers on both sides of the Civil War. Enrollment plummeted during the war, and its future was imperiled, but it survived and still operates today. In July 1863, the Confederate defensive lines established during the retreat from Gettysburg ran through the campus, located south of Hagerstown. (Author's collection.)

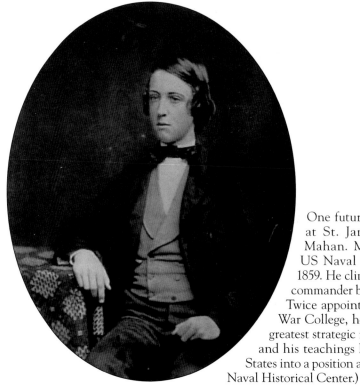

One future leader of men educated at St. James was Alfred Thayer Mahan. Mahan later entered the US Naval Academy, graduating in 1859. He climbed in rank to lieutenant commander by the end of the Civil War. Twice appointed president of the Naval War College, he is considered one of the greatest strategic minds of the 19th century, and his teachings helped propel the United States into a position as a world naval power. (US Naval Historical Center.)

The family of Christian Hawken created a legacy in the firearms industry that has been rivaled only by Samuel Colt. Several generations of the Hawken family were gunsmiths in Hagerstown, dating from the mid-1700s. Christian owned and maintained a gunsmith shop on the southeast corner of West Franklin Street and Prospect Street. Christian's sons Samuel (pictured) and Jacob moved to St. Louis in the 1820s and became legendary for their handmade rifles. The Hawken rifle was popular among buffalo hunters, settlers, and pioneers and it became synonymous with "taming the West." Hawken rifles were owned by such pioneer and Western luminaries as Auguste Lacome, Jim Bridger, Kit Carson, Jedediah Strong Smith, and Theodore Roosevelt. (Byron Family Papers, University of Maryland Libraries.)

Jim Pembroke was raised a slave on the Rockland plantation. Trained as a blacksmith, he escaped in 1827, settled in New York, and assumed the name James W.C. Pennington. He served as a delegate to the World Anti-Slavery Convention in London in 1843 and developed an international reputation as a human rights advocate. A historian of the black experience, Pennington published *The Fugitive Blacksmith* in 1849, which was one of the most popular slave narratives of its time. (Author's collection.)

Rockland still stands, located on the west side of the Sharpsburg Pike in the Tilghmanton area. The area developed its name from the master of Rockland, Col. Frisby Tilghman. Through intermediaries, James Pennington approached Tilghman in 1844 requesting to purchase his freedom, but the $1,000 price offered by Tilghman was beyond his reach. Tilghman died in 1847, and Pennington completed the purchase of his freedom from Tilghman's estate in 1851. (Author's collection.)

Henry O. Wagoner was born in or near Hagerstown in 1816 to a German father and freed slave mother. He was hired in the 1850s by Frederick Douglass as the Chicago correspondent for the *Frederick Douglass Paper*. Wagoner became a close friend of Douglass's. In 1860, Wagoner relocated to Denver, Colorado, and taught civics and government to black citizens in a night school. Later, he was the only African American in his time to serve as a deputy sheriff for Arapahoe County, Colorado. (Author's collection.)

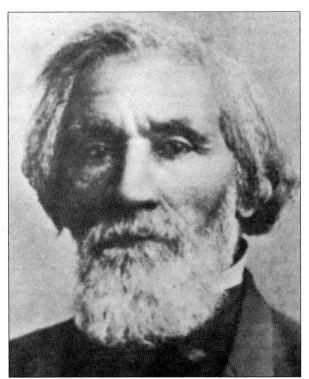

Ann Fitzhugh was born in this home known as "The Hive." It stands today in an abandoned condition north of Chewsville. In 1810, Ann's family moved to upstate New York. She married Gerrit Smith, one of the nation's most prominent abolitionist figures. The Smiths were friends and collaborators with many of the most prominent abolitionists and suffragists of the time. Gerrit was one of the "Secret Six" financiers of John Brown's assault on Harpers Ferry. (Author's collection.)

In June 1859, "Osawatomie" John Brown, a fugitive from "Bleeding Kansas," leased a farm south of Sharpsburg from the estate of Robert Kennedy. It was here that, operating under the alias of "Isaac Smith, prospector," he gathered his band of 21 and planned and launched his ill-fated October raid on Harpers Ferry. Brown's farm still stands and is located on Chestnut Hill Road. (National Park Service.)

Brown also commandeered an abandoned schoolhouse near the farm on the east side of Chestnut Hill Road for use as an arsenal. During the raid, it was guarded by raider John E. Cook. After the raid failed, Marines and militia searched the farm and this schoolhouse and found caches of weapons and documents. This drawing was made by David H. Strother, also known as Porte Crayon, a newspaper artist who witnessed the raid. (Author's collection.)

John E. Cook was the first of John Brown's band to enter the area. He arrived in 1858 as a scout, gathering information on the ways of the local community. When the raid failed, he fled along South Mountain into Pennsylvania, only to be captured at Mont Alto. Ironically, his captor was Hagerstown resident Claggett Fitzhugh, nephew of Ann and Gerrit Smith. Cook was executed for his role in the raid. (National Park Service.)

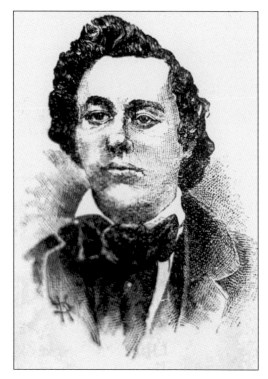

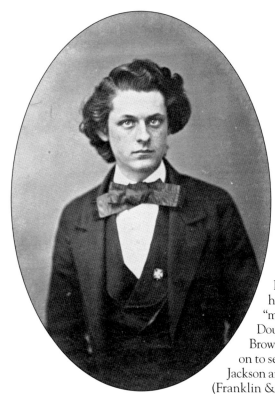

Young Henry K. Douglas could not foresee the adventure that lay before him. Raised at Ferry Hill on the Potomac River near Sharpsburg, he stopped to help an old man whose wagon of "mining tools" was stuck in mud. According to Douglas, unbeknownst to him, he was helping John Brown with a wagonload of weapons. Douglas went on to serve on the staff of Gen. Thomas "Stonewall" Jackson and was wounded six times throughout the war. (Franklin & Marshall College.)

Douglas was the son of an Episcopal minister. Due to the family's Southern sympathies, they were ordered by Union authorities to keep the window shutters on their home closed. When some blew open in a storm, Rev. Robert Douglas was accused of sending signals to rebels across the river, and was arrested and sent to prison at Fort McHenry. This image was taken from Ferry Hill, showing the village of Bridgeport (foreground) and Shepherdstown (background).

Sheriff Edward Mobley led deputies and militia onto South Mountain in search of Brown's fleeing raiders. When Virginia militia occupied Harpers Ferry in 1861, the rebel general commanding implored Sheriff Mobley to keep people off of Maryland Heights to prevent "a collision." Mobley recruited a company of infantry for the Union in 1862 and became its captain. He is pictured here as commander of Company A, 7th Maryland Infantry in 1862. This photograph has never before been published. (Justin Mayhue.)

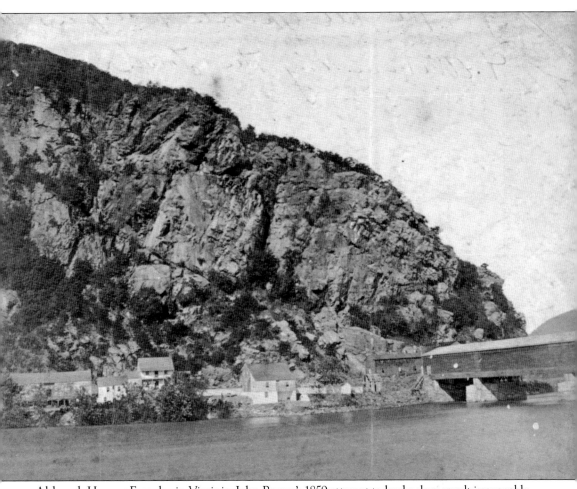

Although Harpers Ferry lay in Virginia, John Brown's 1859 attempt to lead a slave revolt irrevocably tied Washington County to the story. His staging area was in Washington County, as was the route several of his raiders used to escape to the North. Marines and Baltimore militia arrived on the scene at Sandy Hook, just downriver. Harpers Ferry was of critical importance throughout the coming war, being at the confluence of the Potomac River and Shenandoah River. Here, Maryland Heights, in Washington County, towers above the river, illustrating its importance to this soon-to-become vital location. This photograph was taken from Harpers Ferry before the covered bridge was burned by Confederates in their withdrawal from the town in 1861.

THIS DIPLOMA

as given to beck & M.Cammen for the best Horse shoeing

EXHIBITED AT THE

FAIR OF THE AGRICULTURAL AND MECHANICAL ASSOCIATION OF WASHINGTON COUNTY, Md.

October 13th 14th & 15th 1858

The Agricultural and Mechanical Association of Washington County was chartered in 1855 and began hosting a county fair. The fairgrounds was located on land called "Heyser's Woods," on the west side of the Williamsport Pike, just south of Hagerstown. With its good access, shade, water, and proximity to a sizeable town with a rail connection, Union troops camped on the site as early as 1861. Rebels were reported to have camped there during the Gettysburg campaign. The facilities were wrecked by the regular usage by armies, and the fair was suspended for the duration of the war. This site is now part of Hagerstown's City Park. After the war, the association purchased a new fairgrounds on West Church Street. The fair was held there until it was moved in the 1880s to a large tract on the northeast edge of the city. (Sally Artz.)

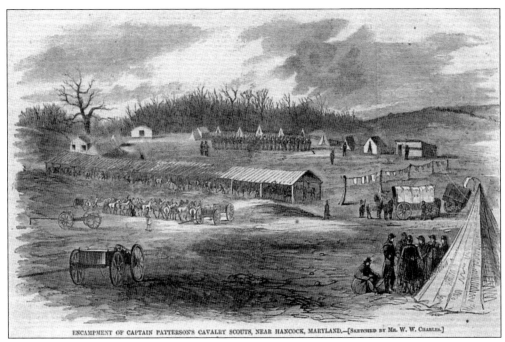

ENCAMPMENT OF CAPTAIN PATTERSON'S CAVALRY SCOUTS, NEAR HANCOCK, MARYLAND.—[Sketched by Mr. W. W. Charles.]

As the armies formed, combat groups were cobbled together from militia groups and volunteer companies that were not yet assigned to regiments. A company of Pennsylvania cavalry commanded by Capt. R.H. Patterson was based at Hancock and was responsible for patrolling the Potomac "frontier" from Hancock to Williamsport. (Author's collection.)

While his men quartered in tents at Camp Jackson outside of town, Col. Samuel H. Leonard of the 13th Massachusetts Infantry procured a house in Williamsport to serve as his quarters and headquarters. A reconnaissance of the streets of Williamsport leads the author to believe that, although somewhat modified, this house still stands at 24 West Potomac Street. (US Army Heritage and Education Center.)

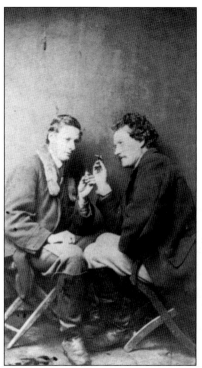

Theodore R. Davis (left) served as an artist-correspondent for *Harper's Weekly*. He followed the Union army in its movements throughout the eastern theater. Several of his drawings of events in Washington County received national exposure when engravings made from them were published. Several of those drawings appear in *Hagerstown in the Civil War*, a companion volume to this book.

In September 1861, Union soldiers noticed the bell atop "John Brown's Fort" in Harpers Ferry. They appropriated it and planned to ship it home for their firehouse. When they broke camp near Williamsport in March 1862, they entrusted the bell to town resident Elizabeth Ensminger. When Confederates arrived in the fall of 1862, she briefly buried the bell in her yard to protect it. In 1892, the men who appropriated the bell visited Antietam. They visited her and asked about the bell. She gave the bell to the veterans, who mounted it on the Grand Army of the Republic post building in Marlborough, Massachusetts. It is now mounted in a tower on Union Common in downtown Marlborough. (Author's collection.)

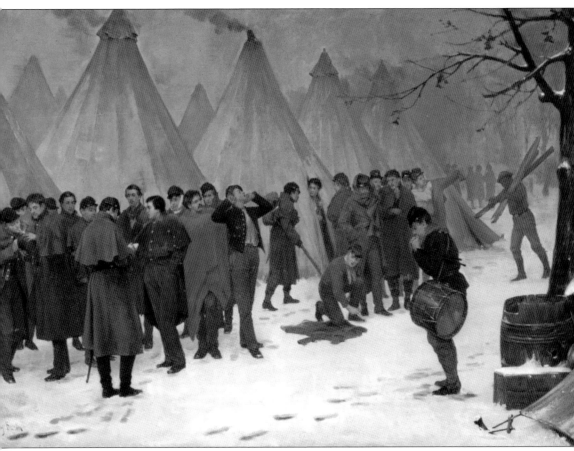

Cpl. Henry Bacon served in the 13th Massachusetts and as an artist-correspondent for *Frank Leslie's Illustrated Newspaper*. He served in the Union army from 1861 until he was wounded at the Battle of Second Manassas in August 1862. His wounds ended his military service, and he resumed his artistic career. Engravings based on his drawings appeared in nationally circulated newspapers early in the war. Bacon went on to become one of the more prominent American artists of the late 19th century. In 1877, he completed this painting, titled *Reveille on a Winter's Morning*. Drawing on his one winter in camp, this painting depicts his regiment's facilities at Camp Jackson at Williamsport during the winter of 1861–1862. It includes certain details unique to his experience, such as the use of conical Sibley tents and the regiment's red blankets. The young drummer is believed to depict Sam Webster, the drummer of Bacon's company. Webster was a Unionist refugee from Martinsburg, Virginia. He joined the regiment in January 1862. (West Point Museum Collection, US Military Academy.)

Century-old Fort Frederick at Big Pool was a ruin by the time of the Civil War. Its remnants were used as farm pens. The only fighting to occur at this location was on Christmas Day 1861, when Company H of the 1st Maryland Infantry fought off an attack by a small rebel force. The site became Maryland's first state park in 1922. The fort has been restored and is open to the public. (Western Maryland Room, Washington County Free Library [WCFL].)

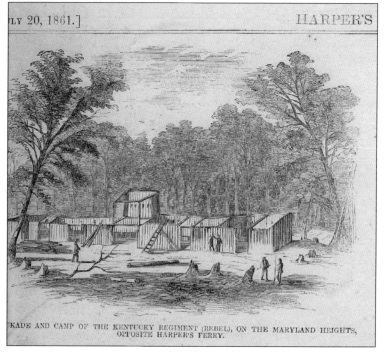

KADE AND CAMP OF THE KENTUCKY REGIMENT (REBEL), ON THE MARYLAND HEIGHTS, OPPOSITE HARPER'S FERRY.

In order to keep Harpers Ferry secure, Gen. Stonewall Jackson ordered Capt. Bradley Johnson and the 1st Maryland Infantry Regiment and Col. Blanton Duncan and the 1st Kentucky Regiment to occupy Maryland Heights, which was officially in enemy territory. This newspaper engraving shows some of the facilities constructed by Duncan's Kentuckians during their brief stay in Washington County. (Author's collection.)

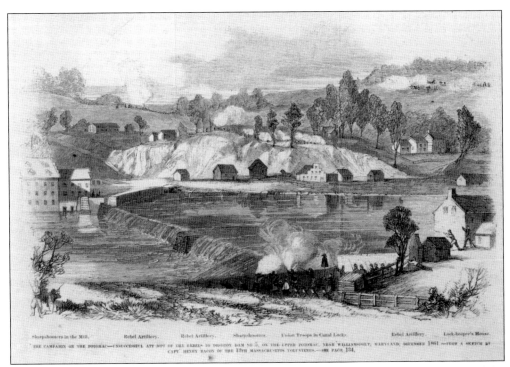

THE CAMPAIGN ON THE POTOMAC—UNSUCCESSFUL ATTEMPT OF THE REBELS TO DESTROY DAM NO 5, ON THE UPPER POTOMAC, NEAR WILLIAMSPORT, MARYLAND, DECEMBER 1861—FROM A SKETCH BY CAPT. HENRY BACON OF THE 13TH MASSACHUSETTS VOLUNTEERS.—SEE PAGE 134.

On December 7, 1861, Confederates under Stonewall Jackson attempted to destroy Dam No. 5 on the Potomac near Clear Spring. While contested only by two companies of the 13th Massachusetts positioned on the Maryland side of the Potomac River, Jackson was successful in only partially damaging the dam. Henry Bacon of the 13th Massachusetts penned the drawing from which this engraving was made. (Author's collection.)

The war brought an economic boom to Hagerstown and the surrounding area. Several photographers offered their services to citizens, visitors, Union soldiers, and to even a few Confederates. The "dean" of Hagerstown photographers was Elias M. Recher, whose studio was on Public Square. This photograph of an unidentified Union sergeant displays Recher's unique painted backdrop that appears in hundreds of surviving photographs of the period. (D. Jeffrey Brown.)

Mary Alice Smith of Greencastle served as a nurse at the hospital in Hagerstown early in the war. She also served at Antietam in 1862 and at Camp Letterman hospital near Gettysburg in 1863. She left nursing at the end of 1864 to marry Marquis Frush, a veteran of the 6th West Virginia Cavalry. (Author's collection.)

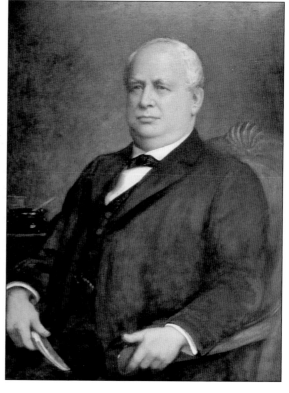

Local attorney Richard Alvey spoke out against forcing the Confederacy to stay in the Union. For his opposition, he was arrested by the Lincoln administration in June 1861 and held as a political prisoner for several months. He was released on parole in 1862. Alvey was a delegate to the Maryland Constitutional Convention of 1867 and held several Maryland and federal judgeship roles during his career. (Circuit Court, District of Columbia.)

Two

THE GREAT CATASTROPHE
1862

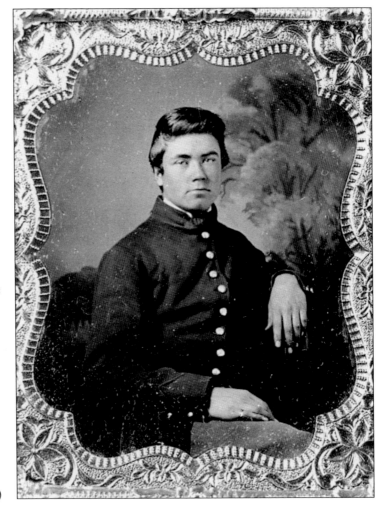

Clear Spring resident James Dorrance enlisted in Company A, 7th Maryland Infantry in 1862. His wartime letters and a diary he kept in 1865 have survived, and the contents were published in *Crossroads of War: Washington County in the Civil War* by S. Roger Keller (1997). Among the most insightful of Dorrance's writings is his account of the death of his friend Cpl. Albert Houck at the Battle of the Wilderness. Dorrance moved to Ohio after the war. (Clear Spring Historical Association.)

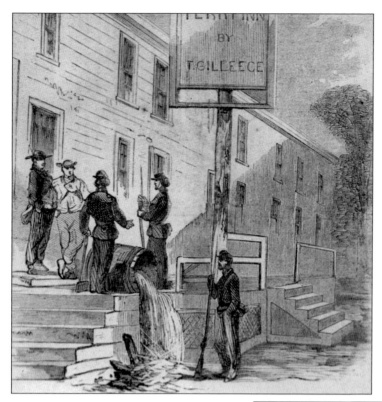

Soldiers provided an influx of outside money to local economies, but trade was restricted at times. In this image from *Harper's Weekly*, military authorities in Hancock destroy Thomas Gilleece's supply of alcohol because he sold it to soldiers, which was prohibited. The Ferry Inn was located in the east part of town, between Main Street and the canal. The area is now occupied by a hardware store and an auto parts store. (Author's collection.)

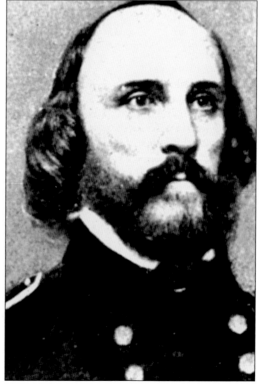

On January 5 and 6, 1862, Confederates under Gen. Stonewall Jackson bombarded Hancock. Union brigadier general Frederick Lander (pictured) stubbornly held his position. Jackson broke off the attack on the 6th, and the battle, which resulted in no advantage on either side, had a total of approximately 50 casualties.

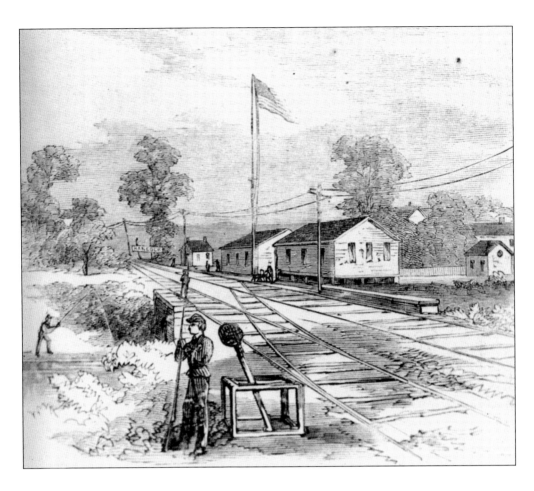

The Chesapeake and Ohio Canal and the Baltimore & Ohio Railroad tightly paralleled the Potomac River at Hancock, increasing the town's strategic value to both sides. The railroad and canal were used for bringing supplies and soldiers from the Midwest into the eastern theater of war. The town was frequently garrisoned throughout the war. In 1862, *Harper's Weekly* provided its readers with this image of soldiers guarding the Baltimore & Ohio Railroad facilities at Hancock. The image below depicts the encampment of the 98th Pennsylvania Infantry Regiment in the hills surrounding Hancock in 1862. The regiment was known as "Ballier's Bully Dutchmen." (Both, Western Maryland Room, WCFL.)

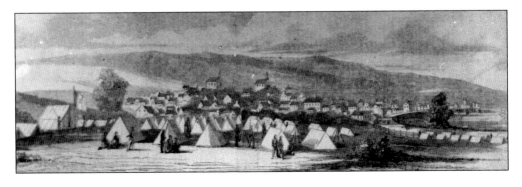

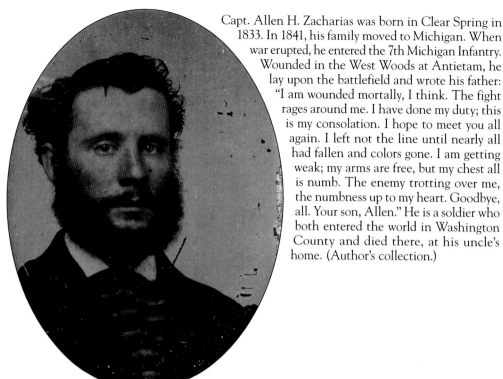

Capt. Allen H. Zacharias was born in Clear Spring in 1833. In 1841, his family moved to Michigan. When war erupted, he entered the 7th Michigan Infantry. Wounded in the West Woods at Antietam, he lay upon the battlefield and wrote his father: "I am wounded mortally, I think. The fight rages around me. I have done my duty; this is my consolation. I hope to meet you all again. I left not the line until nearly all had fallen and colors gone. I am getting weak; my arms are free, but my chest all is numb. The enemy trotting over me, the numbness up to my heart. Goodbye, all. Your son, Allen." He is a soldier who both entered the world in Washington County and died there, at his uncle's home. (Author's collection.)

One of the more widely published images made in the weeks after the Battle of Antietam is this photograph of a US Army Signal Corps station on Elk Ridge. It was southeast of Sharpsburg and Keedysville. The Signal Corps was a new branch of the service that Capt. William J.L. Nicodemus of Clear Spring had a strong hand in piloting toward its permanent role in the structure of the Army.

The first major battle in Maryland occurred on September 14, 1862, on South Mountain. A delaying action in three mountain passes, it allowed Robert E. Lee to consolidate his army around Sharpsburg to await the Union advance. Lt. Col. George S. James was the artillery officer who fired the first shot at Fort Sumter. He was killed at Fox's Gap and lies in an unknown soldier's grave in Washington Confederate Cemetery in Hagerstown. (National Park Service, Fort Sumter National Monument.)

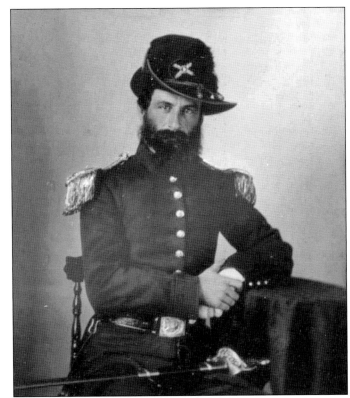

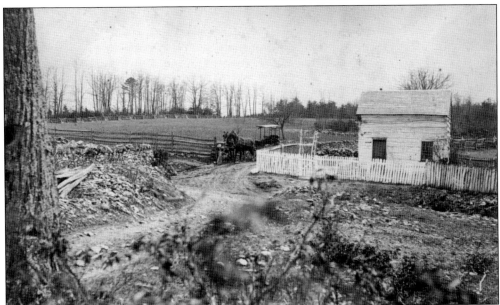

Combat was fierce on Daniel Wise's farm, located in Fox's Gap. Here, future president Rutherford Hayes was wounded while commanding the 23rd Ohio Regiment. A second future president, William McKinley, was a sergeant in Hayes's regiment. Two generals were mortally wounded here, Union major general Jesse Reno and Confederate brigadier general Samuel Garland. The area had changed little from the battle when this photograph was taken in 1889. (Stephen Recker.)

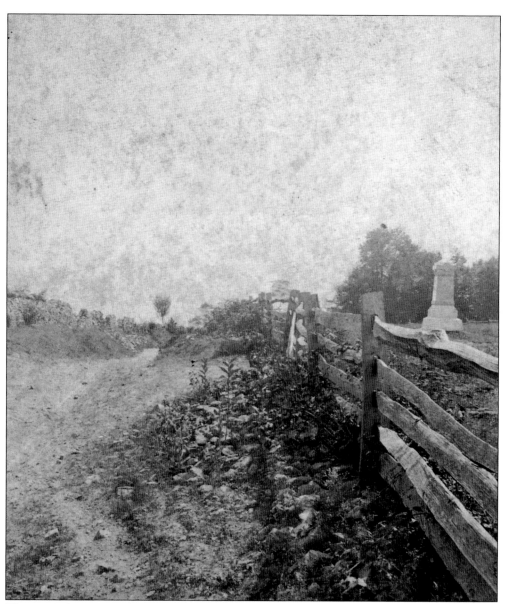

This c. 1895 image, with a view looking east on what is now Reno Monument Road in Fox's Gap, was taken from the location of Wise's Cabin. Lamb's Knoll Road is behind the cameraman, extending to the right. It was through this area that the brigades of Orlando Willcox and Jacob Cox, charged against rebels who were desperately trying to buy time for the dispersed Confederate divisions to assemble. It was here that Maj. Gen. Jesse L. Reno was mortally wounded. When Reno was seen by his friend Gen. Samuel Sturgis, he is reported to have said "Hallo, Sam! I am dead!" When Sturgis expressed his hope that the wound was not as bad as he feared, Reno said, "No, I am dead. Good-bye." The monument erected to Reno's memory can be seen to the right of the road. (Kevin Boyer.)

Thirteen-year-old Johnny Cook enlisted as a bugler in Battery B, 4th US Artillery in 1861. At Antietam, he helped a wounded officer off the field, and when he returned, he found one of his battery's guns unmanned due to casualties. Cook jumped from his horse and single-handedly served the piece until others came to assist—among whom was Brig. Gen. John Gibbon. Due to the crisis, General Gibbon served one of the guns like a common private. Cook is one of the youngest soldiers ever to earn the Medal of Honor. (National Park Service.)

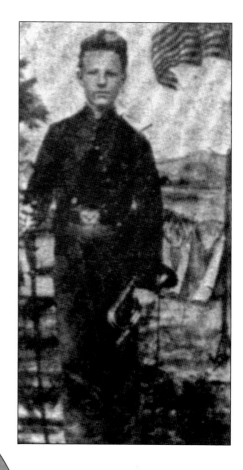

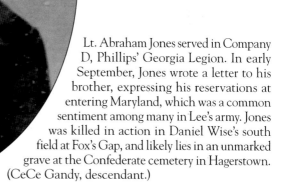

Lt. Abraham Jones served in Company D, Phillips' Georgia Legion. In early September, Jones wrote a letter to his brother, expressing his reservations at entering Maryland, which was a common sentiment among many in Lee's army. Jones was killed in action in Daniel Wise's south field at Fox's Gap, and likely lies in an unmarked grave at the Confederate cemetery in Hagerstown. (CeCe Gandy, descendant.)

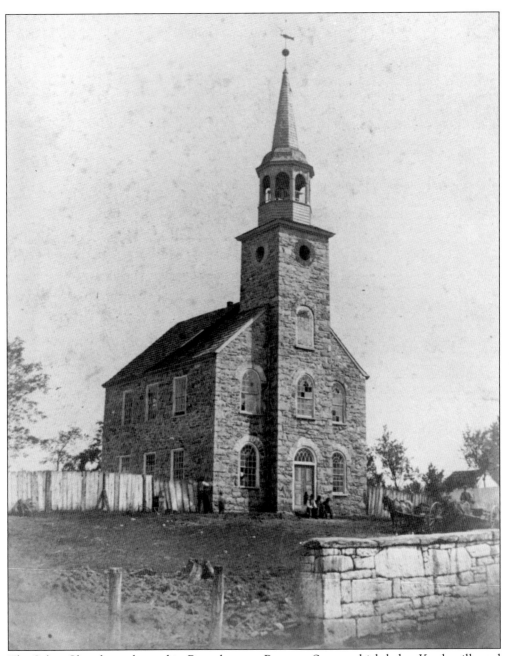

The Salem Church was located in Boonsboro on Potomac Street, which led to Keedysville and Sharpsburg. It was demolished and rebuilt not long after the war. The newer building is the home of the Trinity Reformed United Church of Christ. Salem Church was used as a hospital in the wake of the Battle of South Mountain. (Doug Bast, Boonesborough Museum of History.)

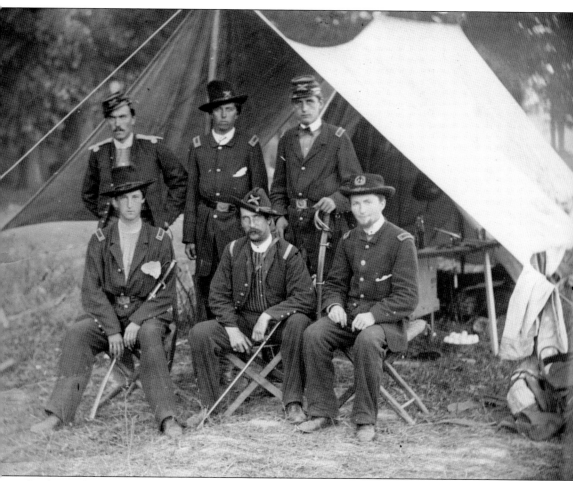

In the weeks and months after the Battles at South Mountain and Antietam, the Army of the Potomac remained in the county, cleaning up the debris, burying the dead, and caring for the wounded, but not following the enemy. Here, six artillery officers pose for a photograph in their camp in Washington County in the fall of 1862. The young artillerist in the center of the back row is Lt. Alonzo Cushing. Cushing was killed in action on July 3, 1863, at the Battle of Gettysburg while in command of his decimated battery as it fought desperately to repel "Pickett's Charge." Although it is extremely unusual for the US government to do so after the passage of so many years, Pres. Barack Obama posthumously awarded the Medal of Honor to Cushing in 2014.

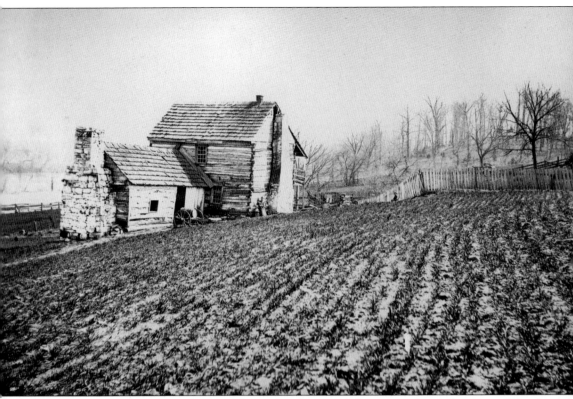

The Piper farm was located west of the sunken farm road that is now forever known as "Bloody Lane." The area was used by Gen. James Longstreet for a headquarters during part of the battle. The North Carolinians who were forced out of the Bloody Lane rallied here, creating a defensive line that the Union troops did not press. This photograph of the farm was taken in 1889 and was owned by army surgeon Solomon McFarland. McFarland worked at the Smoketown Hospital but became ill and was cared for at the Piper farm. According to his note on this photograph, he was quartered in the rear kitchen wing, beneath the window. (Stephen Recker.)

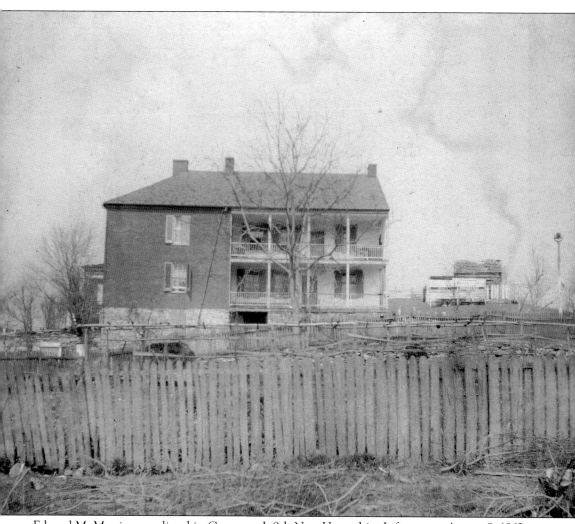

Edward M. Messinger enlisted in Company I, 9th New Hampshire Infantry on August 8, 1862. Thirty-nine days later, he fell wounded in the fighting around Burnside's Bridge. In April 1900, Messinger returned to Antietam and took this photograph of the Jacob F. Miller farm "where I was carried after the Battle of Antietam." The Miller farm is located to the southeast of Burnside's Bridge. The entire area from Keedysville to the Potomac River held a series of improvised hospitals. (Kevin Boyer.)

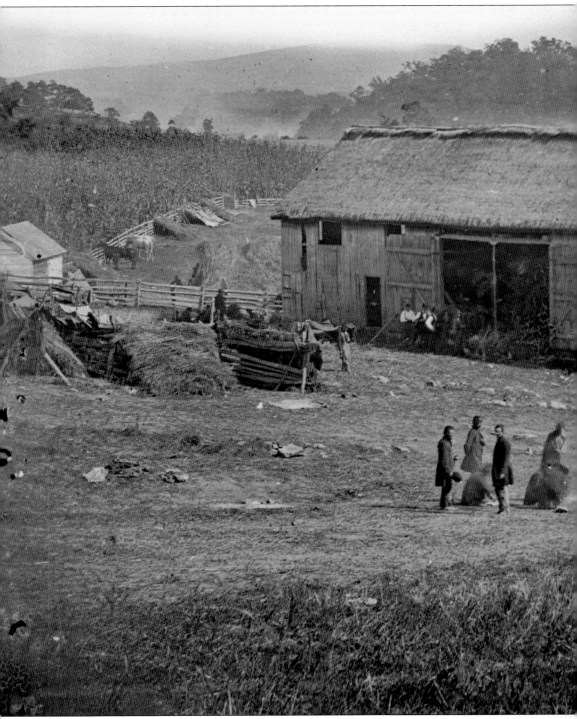

Barns and barnyards were frequently pressed into service for hospital use. Here, the Smith farm near Keedysville is shown serving as a field hospital in the weeks after Antietam. While efforts were made to relocated the ambulatory wounded and others who could be moved to permanent hospitals in Frederick, Baltimore, Washington, Harrisburg, and Philadelphia, hundreds of men

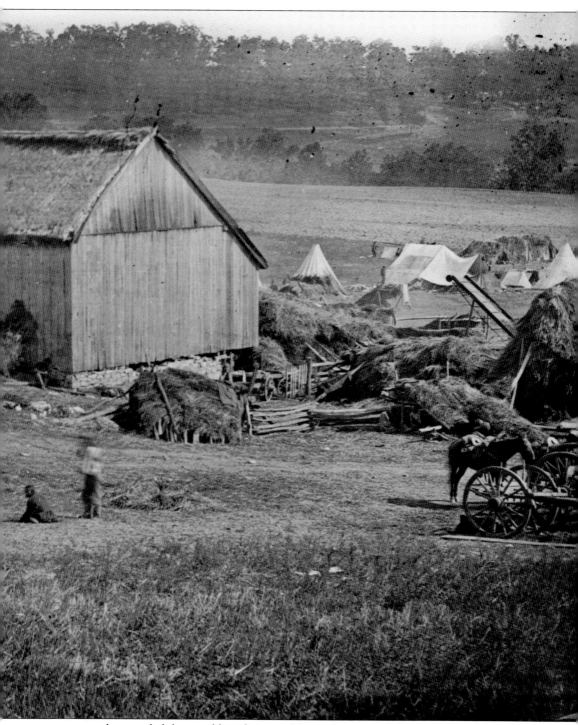

were so severely wounded they could not be moved for weeks or months. The straw-covered lean-tos and huts shown throughout the barnyard and paddocks were erected to shield the wounded from the sun and weather and even early snow that arrived as winter approached.

To one degree or another, the entire south county area hosted wounded and sick soldiers. The heaviest concentration of field hospitals was the area in the northern battlefield and Keedysville. Photographer Alexander Gardner captured Dr. Anson Hard of the 14th Indiana Infantry outside of his field hospital made of "shebangs." A shebang was an improvised tent cobbled together from blankets, gum blankets (ponchos), and shelter halves, supported on bayoneted muskets driven into the ground.

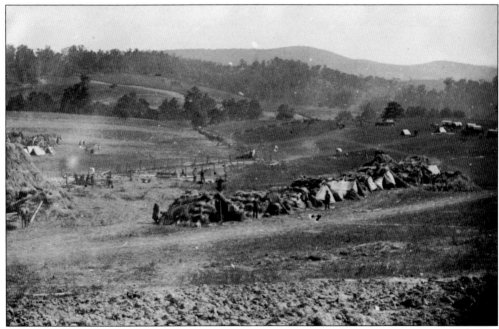

Another image captured by Gardner shows a row of straw huts located on the Keedysville farm of the Smith family, which functioned as a hospital ward for some of the most severely wounded soldiers in the wake of the Battle of Antietam. Some soldiers were so fragile in their condition that they could not be moved for many weeks after the battle.

Antietam was the first major action in the East where the Union army was left in possession of the battlefield. As they tended to the wounded and buried the dead, the army and local civilians were besieged by gawkers who visited the battlefield out of morbid curiosity. Also, hundreds of panic-stricken relatives of wounded Union soldiers flooded into the region searching for their wounded loved ones, which burdened already depleted resources. (Author's collection.)

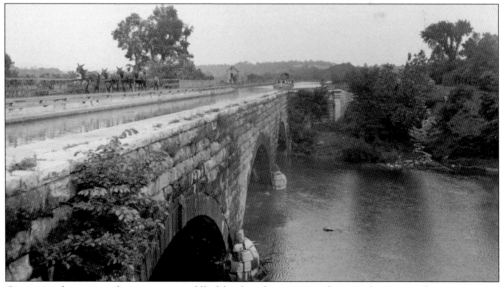

On a canal, an aqueduct is a water-filled bridge that carries the canal over a tributary stream. They were valuable targets for destruction as they were hard to repair. Here, a mule team pulls a canalboat across the Conocoheague Creek above Williamsport around 1900.

Wounded in the neck, Capt. Oliver W. Holmes Jr. found his way to Hagerstown. He was taken in by Frances Kennedy at her home, Rochester House. After several days, Holmes moved north on the Franklin Railroad in order to recuperate at home and be one less wounded soldier for the army and community to care for in the wake of the disaster. Holmes later served as an associate justice of the US Supreme Court. (Author's collection.)

When Oliver's father, Oliver Wendell Holmes Sr. (a famous poet), learned that his son had been wounded, he traveled from Boston to Baltimore, then Middletown seeking to care for him. He searched the hospitals at Smoketown and Keedysville without success. He finally caught up with his son in Harrisburg. Weeks later, he published an article in *Atlantic Monthly*, titled "My Hunt for the Captain," which details his travels through the war zone. It became one of his more renowned works. (Harvard University Library.)

Anna Kennedy was a young girl when the wounded flooded into Hagerstown from Antietam. She aided her mother in caring for the wounded Union officers who were brought into their home. The Kennedy residence, known as Rochester House, was located on the southwest corner of West Washingotn and Prospect Streets. Anna later wrote of her experiences. (Washington County Historical Society.)

Daniel M. Trittle enlisted with many other county citizens in Company A, 7th Maryland Infantry in August 1862. He served throughout the rest of the war. Conflicting accounts suggest he may have been wounded in the Battle of the Wilderness. When he was mustered out with the regiment at Arlington, Virginia, at the end of May 1865, he held the rank of corporal. (D. Jeffrey Brown.)

Lt. John L. "Piney" Oden of the 10th Alabama Infantry (left) was seriously wounded in the leg by a shell. After the battle, he scribbled a note and gave it to a Union soldier, asking that it be given to a Freemason. A "brother" in the Union army saw to it that Oden was taken to Hagerstown, where he was made comfortable in the courthouse, surrounded by many Union wounded. He was the only rebel in the courthouse hospital. (David Purcell, descendant.)

Many large buildings throughout the area served as hospitals. The county courthouse was no exception. Dozens of union soldiers and officers were transported to this building and cared for until they could be moved elsewhere. According to accounts, the only rebel confined in this hospital was Lt. John Oden. (Washington County Historical Society.)

Mollie MacGill (standing, with her sister Alice) visited the courthouse with her brother, who was a doctor. Southern sympathizers, they asked to take Oden to their home to care for him. Although it was thought his wounds were mortal, Oden survived due to Mollie's care. He returned to Alabama, and when he became the father of a daughter a few years later, the child was named Mollie MacGill Oden. (Valerie MacGill Melville, descendant.)

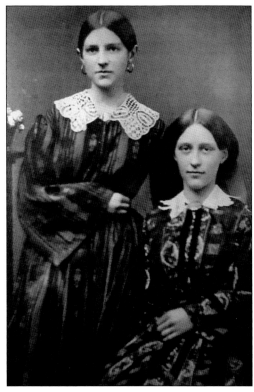

Antietam was the first major campaign in which Dr. Jonathan Letterman's system for organizing for the care of mass casualties was put to the test. Numerous aid societies augmented the army's efforts. In the waning hours of the battle, Clara Barton was so close to the action that bullets perforated her clothing as she cared for the wounded. Barton later went on to found the American Red Cross.

Isabella Fogg of Calais, Maine, was a volunteer with the Maine Camp and Hospital Association. On November 1, she reached the hospitals at Smoketown and Sharpsburg and was appalled with what she found. Weather had turned cold and an early snow fell, and many men, still too fragile to move, tried to recover from their wounds on the ground and in tents. (Maine State Archives.)

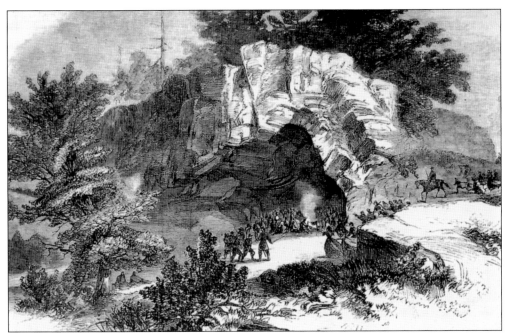

When it became apparent a great battle was brewing, the residents of Sharpsburg either took to their basements or fled. Dozens of local residents sought shelter in Killiansburg Cave, located on a bluff along the Potomac River, north of Shepherdstown and south of Snyders Landing Road. It is not open to the public. (Author's collection.)

After they returned from sheltering in Killiansburg Cave, the Morrow family found a wounded Confederate soldier, wrapped in a quilt, on the front porch of their home on East Chapline Street. Having sat vacant for years, this home was recently restored and now appears much as it did then. (Author's collection.)

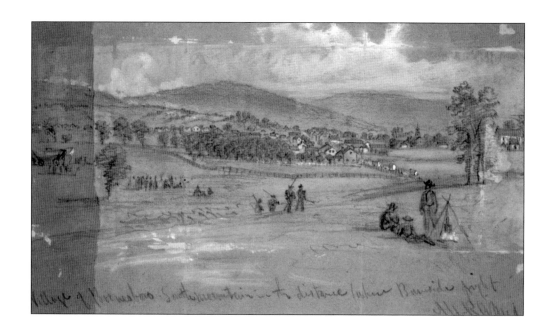

Artists traveled with the armies, making sketches of important events. Their drawings were "expressed" to their newspaper offices in the cities, where engravers would make woodcut illustrations for publication based on those drawings. Alfred Waud sketched the above scene for *Harper's Weekly*. The woodcut illustration below was published in the October 25, 1862, issue of *Harper's Weekly* based on Waud's drawing. From its position, it would appear that he made the sketch roughly from the current location of Boonsboro High School.

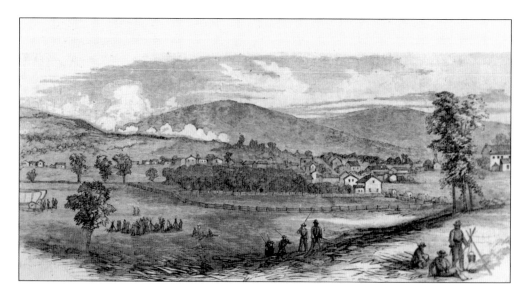

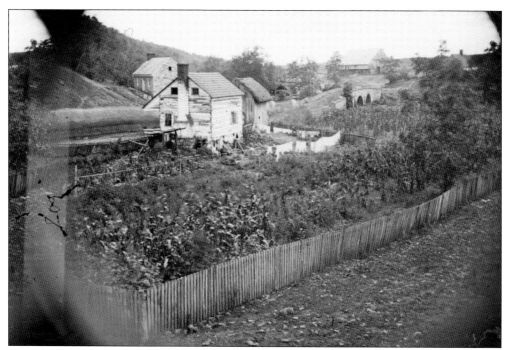

The Middle Bridge is one of the most popular features used in illustrating the Battle of Antietam. Located across the Antietam Creek on the road that links Sharpsburg and Keedysville, this area was captured in images in the days after the battle. This is one of the lesser-known photographs of several that were taken in this area.

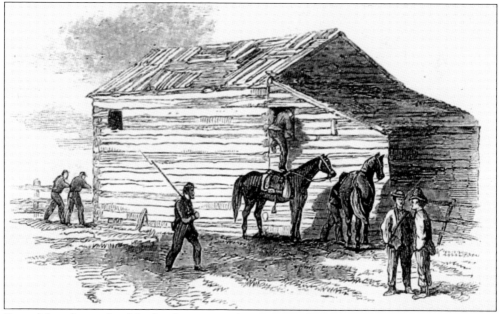

Part of the aftermath of the battle was rounding up stragglers. Here, a newspaper artist depicts Union cavalrymen searching a corncrib somewhere in Washington County to make sure it is not being used as a refuge by straggling rebels trying to make their way back to Lee's army. (Western Maryland Room, WCFL.)

As the two wounded armies maneuvered, never was communication more important. This image depicts a makeshift signal tower on Union-held Maryland Heights above Harpers Ferry that had views of signal stations for miles around. (Western Maryland Room, WCFL.)

In August, when Washington Countians formed Company A of the 7th Maryland Infantry, Captain Mobley knew he could count on one recruit, his son Carver. Father-son pairs in Civil War regiments were not uncommon. The 7th Maryland was hastily trained in Baltimore and reported for duty in late September to help in the cleanup and occupation of the Antietam area. (Justin Mayhue.)

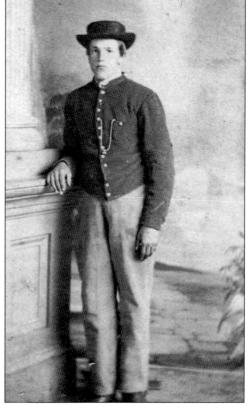

The Battle of Antietam created terrible health conditions in the county. In early 1863, Hagerstown hired Jacob Wheaton to serve as a nurse at a smallpox hospital that the town established to treat victims of that illness, which was sweeping the African American community. Wheaton accomplished several "firsts" in his lifetime—the most prominent was that he became the first African American to vote in Maryland after the Civil War, in 1868. (Bronson Wheaton McCurdy, descendant.)

As events stabilized, family members of high-ranking Union officers visited the camps. The Garrott home in the Brownsville area hosted the wife of General McClellan during her stay. Pictured are, from left to right, Amada Brown, a Garrott family slave; William Garrott, nephew of the owner; unidentified; two officers from General Burnside's staff; unidentified; Irene Williams; and her father, Gen. Alpheus Williams.

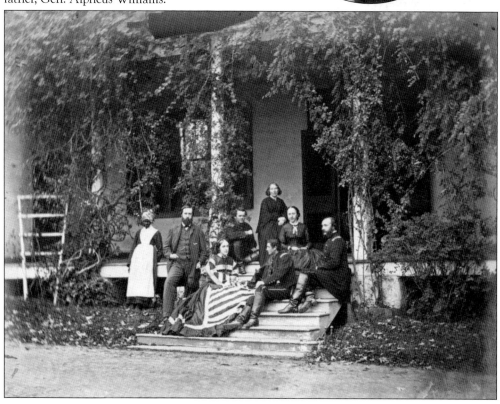

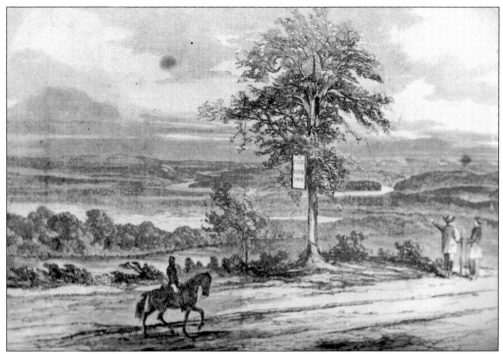

Although the rebels were turned back at Antietam, they were still a potent threat. Here, *Frank Leslie's Illustrated Newspaper* published a drawing made from the top of Fairview Mountain, with a view looking toward Hancock and the Potomac River. The tufts of smoke in the valley depict Confederates destroying Baltimore & Ohio Railroad rolling stock along the river in the weeks after Antietam. (Western Maryland Room, WCFL.)

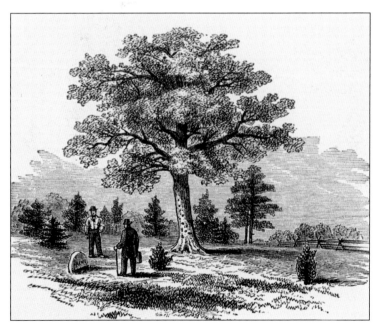

It took many years for the battlefields to recover from the scarring inflicted by warring armies. In this newspaper illustration, the battlefield on South Mountain shows the scars of battle and the small monument erected by the Wise family to honor Union general Jesse L. Reno, who was killed in the action near their home. (*Pictorial History of the Civil War in the United States of America* by Benson John Lossing.)

With the close of 1862, Washington County faced scenes like this for years. Here, the graves of soldiers of the 51st New York Infantry, marked by the carved lids of ammunition boxes, lie in the shadow of Burnside's Bridge—a bridge they died trying to capture. As the county would be fought over for two more years, scenes like these dotted the landscape from Maryland Heights to Smithsburg to Hancock.

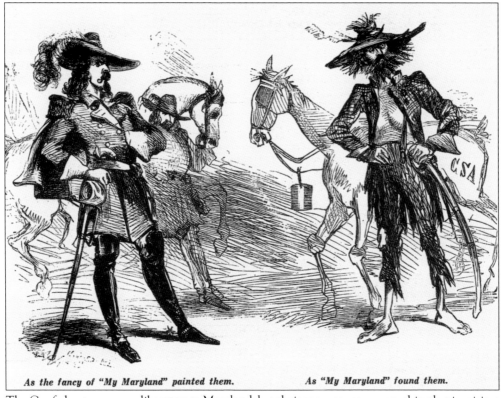

As the fancy of "My Maryland" painted them. *As "My Maryland" found them.*

The Confederates came as liberators to Maryland, but their appearance was anything but inspiring. With the Confederate quartermaster service slow to organize early in the war and after many weeks of campaigning, the rebels were in the worst physical condition at Antietam that they would likely be at any time during the war. This cartoon relates what Marylanders expected to find when rebels showed up in their neighborhood and the reality. (Author's collection.)

After the Battle of Antietam, the Hagerstown Female Seminary was commandeered for use as a military hospital for captured Confederate wounded. It was used for this purpose for several weeks. In 1861, it had served as Gen. Robert Patterson's headquarters and a hospital for sick soldiers. After Gettysburg, it was again used as a hospital for wounded rebels. The building became the second home of the Washington County Hospital. (Author's collection.)

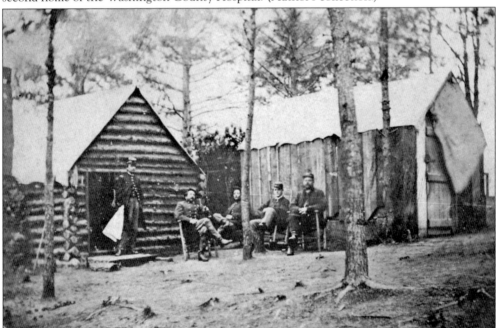

After several weeks, the Army of the Potomac left Maryland, looking to place itself back into Virginia to operate on rebel territory. After a terrible slaughter at Fredericksburg, the Union army hunkered down into winter camp. Little campaigning occurred in the winter. Here, Maj. Edward M. Mobley of Hagerstown and officers of the 7th Maryland Infantry are pictured outside of their winter quarters near Culpeper, Virginia. (Charles "Jim" Mobley, descendant.)

Three

THE PATH
FROM GETTYSBURG
1863

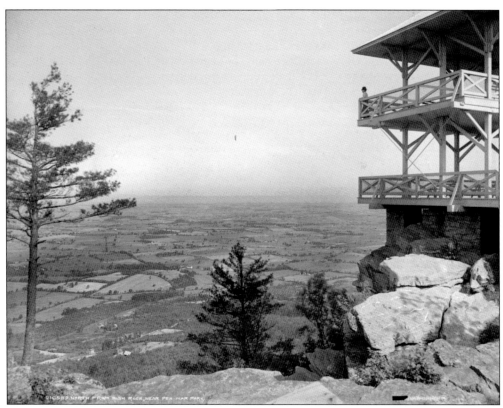

On the night of July 4–5, 1863, a running battle occurred between Union cavalry and a small rebel force guarding wagon trains at Monterey Pass, just north of the state line. The rebels retreated through Rouzerville, Waynesboro, and Ringgold, and Union horsemen caught and burned a wagon train on the road between Ringgold and Leitersburg. This photograph, taken from the High Rock tower around 1900, shows the valley through which blue and gray columns snaked on their way to the Potomac 35 years earlier. Waynesboro is the town visible in the background.

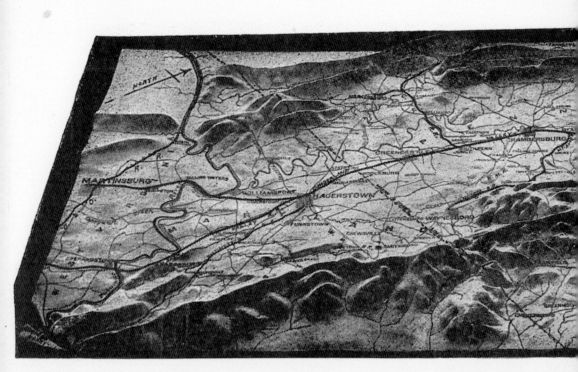

This three-dimensional map is the best possible illustration of the importance of Washington County and the Cumberland Valley in the Gettysburg Campaign. As Lee moved north, he used the South Mountain range to mask his advance into Pennsylvania. When fortune turned against the Confederates, that same mountain range that protected their advance became their second-greatest obstacle in reaching safety. Only the rain-swollen Potomac River was a greater

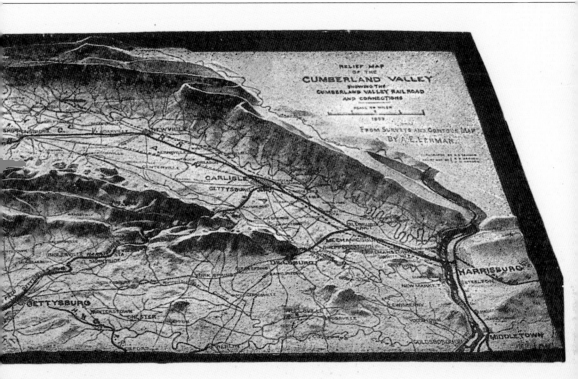

RELIEF MAP
OF THE
CUMBERLAND VALLEY
SHOWING THE
CUMBERLAND VALLEY RAILROAD
AND CONNECTIONS
1899
FROM SURVEYS AND CONTOUR MAP
BY A. E. LEHMAN

TYSBURG CAMPAIGN.
HMAN FOR THE CUMBERLAND VALLEY RAILROAD COMPANY.

natural threat to the retreating Confederates. The topography of the battlefield is an important factor in all military campaigns. The simplest military doctrine dictates that strength is derived from holding high ground and using it to mask one's movements. (*Battles and Leaders of the Civil War*, Century Company, 1887.)

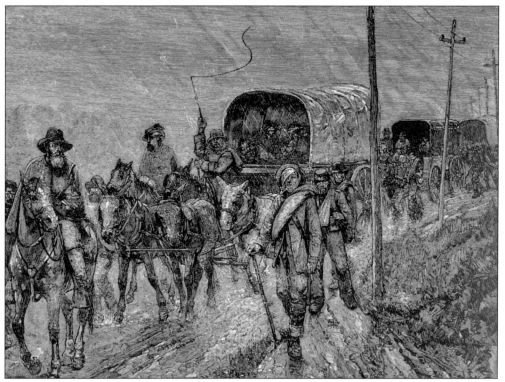

The entire retreat maneuver from Gettysburg to Williamsport was conducted in the wake of a tropical storm that drenched the area from July 4 to July 6. Additional rains pelted the area in ensuing days. The roads used by both forces to crawl across the landscape were nearly impassible bogs. (*Battles and Leaders of the Civil War*, Century Company, 1874.)

On July 5, James Ewell Brown "Jeb" Stuart's Confederate cavalry and Judson Kilpatrick's Union cavalry clashed around the northeast county towns of Smithsburg and Cavetown. Artillery rounds dropped into Smithsburg during the fight. The skirmish occurred when Stuart crossed South Mountain at Raven Rock and ran into the Union troops at the base of the mountain. The Unionists moved on to Boonsboro while the Confederates moved toward Leitersburg. (Stephen Recker.)

A second column of rebel wagon trains headed toward Chambersburg, turned south, and entered Maryland below Greencastle en route to Williamsport. On July 5, Capt. Abram Jones led 200 men of the 1st New York and 12th Pennsylvania cavalries in attacking the wagons at Cunningham's Crossroads (now Cearfoss). Jones made off with 134 of the wagons, 600 horses and mules, 645 prisoners (mostly wounded being transported in the wagons), and two cannons. (Eric Wittenberg.)

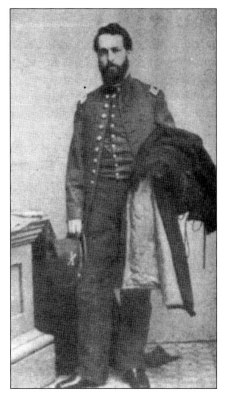

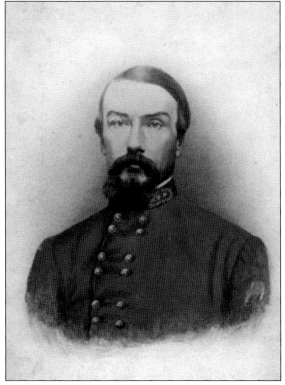

Col. Collett Leventhorpe of the 11th North Carolina Infantry was severely wounded in the hip and arm at Gettysburg. He was evacuated in the wagon trains moving toward Williamsport when Captain Jones overran the rebels at Cunningham's Crossroads. Leventhorpe was held as a prisoner of war for nine months until he was exchanged. He was promoted to brigadier general near the end of the war. (Author's collection.)

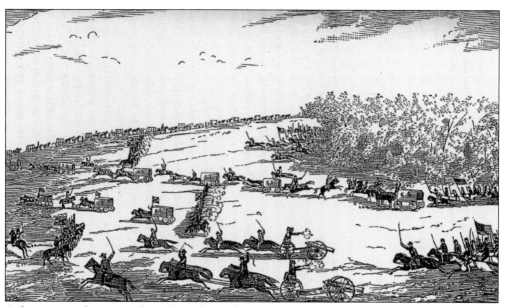

A footnote in the retreat from Gettysburg, the actions at Cunningham's Crossroads (Cearfoss) nonetheless garnered some press attention. Here, a newspaper woodcut illustrates the dash of Union cavalry that overran the Confederate wagons and their guards. Eight Confederate soldiers who died in this event were buried in the Broadfording Church Cemetery. (Eric Wittenberg.)

Confederate cavalry entered Hagerstown on July 6 as Nathaniel Richmond's brigade of Union cavalry entered from the direction of Funkstown. A six-hour fight ensued in which many Union cavalrymen were trapped in the yards and properties they fought through. Ellen Mobley, wife of Maj. Edward Mobley, took several men from the 1st Vermont Cavalry into her home on East Washington Street and hid them for several days until Union troops reoccupied the town. (Justin Mayhue.)

As cavalrymen slashed their way through the streets of Hagerstown, Mary Louisa Kealhofer hid in the basement of her home, listening to the commotion in the streets above. A Southern sympathizer, she feared for the safety of friends serving in the Maryland Confederate troops. The day before the battle, she wrote the following in her diary: "Last night I felt as if my brain was on fire—the constant anxiety is fearful to one deeply interested." (Byron Family Papers, University of Maryland Libraries.)

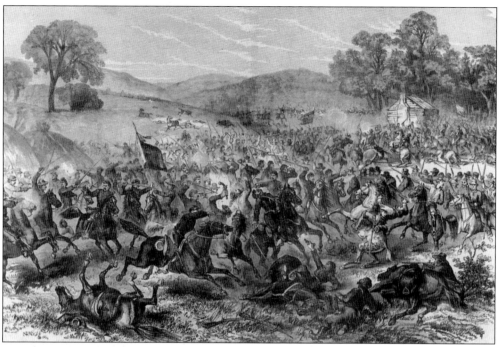

On July 8, one of the largest cavalry battles of the eastern theater developed along the National Road, northwest of Boonsboro. Stuart's rebel cavalry and Pleasanton's Federals clashed as the Yankees tried to push toward Funkstown and Hagerstown. (Western Maryland Room, WCFL.)

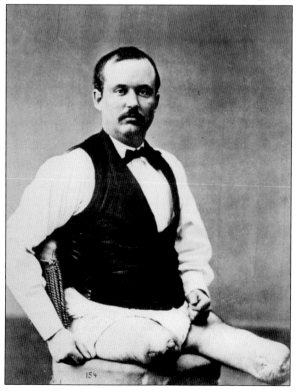

While Civil War combat sometimes is thought to be almost romantic, there was a human cost. Charles Lapham of the 1st Vermont Cavalry was grievously wounded when an artillery round passed through his horse, mangling his legs. Double amputation was performed on July 10, and he was cared for in the Boonsboro home of Nancy Stotler. He was discharged, attended college, and became a clerk in the US Treasury Department. (National Museum of Health and Medicine.)

On July 10, cavalry and infantry clashed in the fields south and east of Funkstown. Jeb Stuart established a line to protect the Confederate occupation of Hagerstown. Union forces under Gen. John Buford launched a daylong confrontation that resulted in almost 500 casualties. One of those was Tommie Metcalfe of the Phillips' Legion of Mississippi Cavalry from Georgia. Metcalfe was mortally wounded in the head. He was buried in the Hagerstown Presbyterian Church Cemetery. (Margaret Metcalfe Hassin, descendant.)

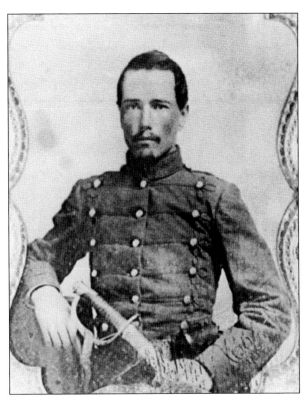

Maj. Henry McDaniel of the 11th Georgia Infantry was 26 years old when he was shot in the abdomen at Funkstown. He was taken to the Wroe home on South Prospect Street in Hagerstown where he was captured. McDaniel insisted on being taken with his men to prison in spite of his critical condition. He survived his wounds and went on to both serve as governor of Georgia and found the Georgia Institute of Technology.

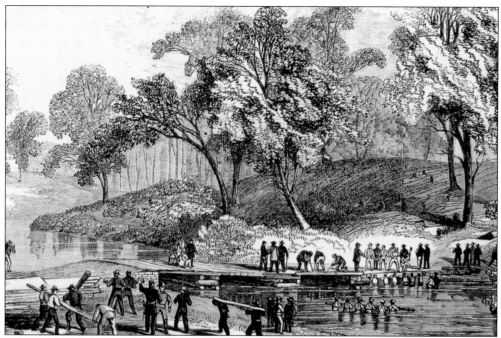

After the Confederates were swept from east of Hagerstown, Union troops moved toward Williamsport. The rebels had their backs to a swollen Potomac River and dug in, while the Union army did the same in a line that paralleled the Sharpsburg Pike. Here, Union army engineers construct a temporary bridge across Antietam Creek on the west side of Funkstown. (Author's collection.)

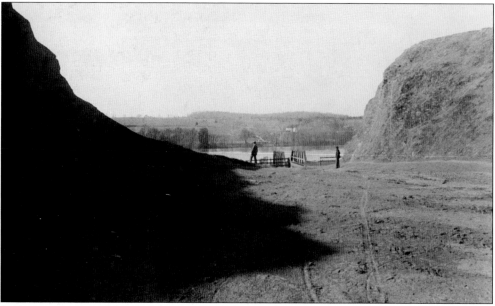

Lee's army was spread from Hagerstown to Falling Waters, protecting the Williamsport crossing. The "Williamsport Cut" provided access from the town on the high ground down to the Potomac River crossings. Doubleday Hill is to the left, with Berkeley County, West Virginia, in the background. (Stephen Recker.)

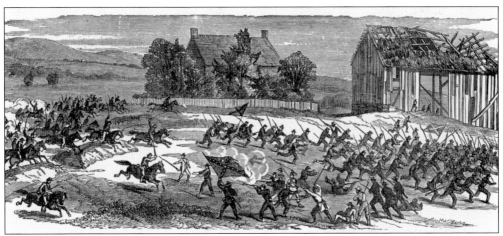

On July 14, the Confederate rear guard at Falling Waters, below Williamsport, was attacked by George A. Custer's Michigan Cavalry Brigade. The fighting swirled around the Daniel Donnelly farm, where James Johnston Pettigrew's troops were preparing to withdraw. The Confederates mistook Custer's "Wolverines" for their own cavalry, and before they could respond, they were overwhelmed.

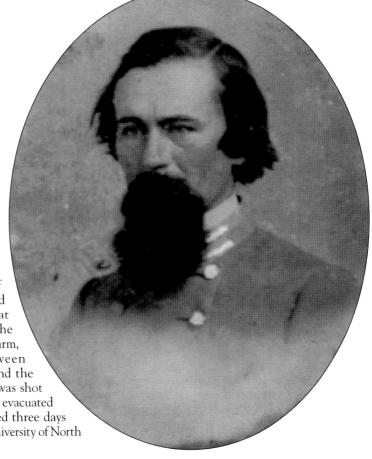

Gen. James J. Pettigrew commanded one of the divisions involved in Pickett's Charge at Gettysburg. During the fight at the Donnelly farm, Pettigrew was between the Donnelly house and the vacant barn when he was shot in the abdomen. He was evacuated across the river and died three days later at Martinsburg. (University of North Carolina Library.)

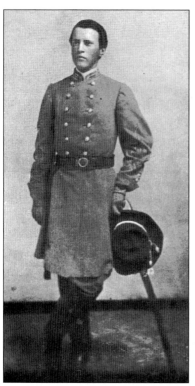

Company F of the 21st Virginia was in the Martinsburg area on detached service during the Battle of Gettysburg. When their retreating comrades began arriving at the Williamsport crossing, the men crossed into Maryland on July 5 to help cover the retreat. On the evening of July 6 during Buford's attack on the Confederate wagons, Company F left its position on the northwest side of town and charged about 400 yards to secure a strategic farm complex. Soon after the seriously outnumbered men of Company F seized their objective, their commander, Capt. William A. Pegram, fell while fighting the Union cavalry. (Robert Ambrose.)

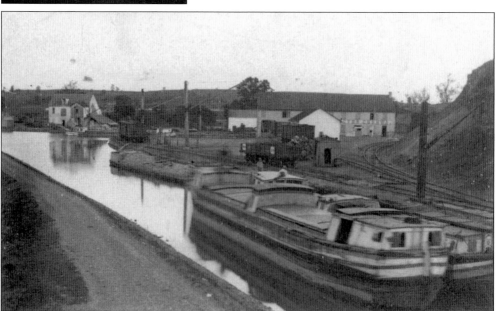

The Williamsport flats, located near the current US Route 11 crossing of the Potomac River and Riverview Cemetery, was the primary location for the assemblage of Lee's wagons and ambulances in their attempt to cross the river to safety after Gettysburg. Torrential rains on July 4 through 6 flooded the Potomac, trapping the rebels on the north side of the river and forcing Lee to construct defensive works around the town. After the floodwaters subsided, the Army of Northern Virginia completed its evacuation of Maryland on July 14. (Washington County Historical Society.)

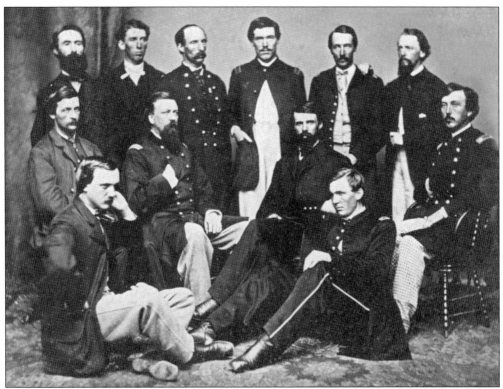

Custer's Michigan Cavalry Brigade charged toward the Falling Waters pontoon bridge and overwhelmed Confederate defenders around the Daniel Donnelly house; the rebels were serving as a rear guard protecting the forces crossing into Berkeley County. James Longstreet's and A.P. Hill's corps crossed at Falling Waters while Richard S. Ewell's corps crossed farther upstream near Williamsport. Maj. Peter Weber (standing, center) and Lt. Charles Bolza (standing, far right) of the 6th Michigan Cavalry were in the thick of the fight and were struck down leading their men. In this photograph, Weber and Bolza sit with other officers of the 5th and 6th Michigan Cavalry Regiments. Lieutenant Bolza rests today in Antietam National Cemetery. (David Finney.)

As the national newspapers were distributed weekly, information was not close to real time. Images from the campaign through Washington County appeared in the press for weeks after the campaign ended. Here, a rather fanciful image of the cavalry battle at Boonsboro masks the carnage encountered by soldiers like Charles Lapham. (Author's collection.)

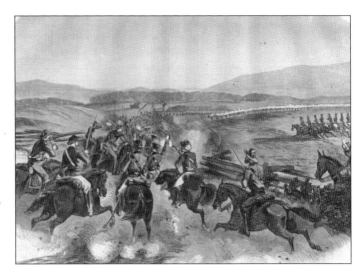

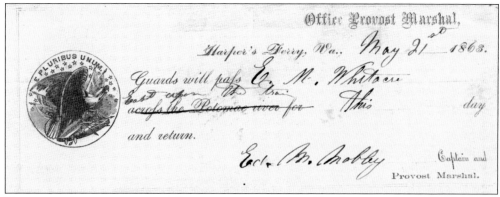

During a military occupation, all movement is monitored by the army through the provost marshal's office. The provost marshal was typically an officer of a regiment in the area assigned to this duty. Maj. Edward Mobley was assigned at times to serve as provost marshal of Harpers Ferry and of Williamsport. (Justin Mayhue.)

During the Battle of Hagerstown on July 6, Lt. Eugene Dimmick was seriously wounded leading his troops in the 5th New York Cavalry. He recovered and, in 1865, commanded the honor guard at Albany when President Lincoln lay in state there. Dimmick went onto a career in the US Regular Cavalry, even commanding elements of the 9th US Cavalry (Buffalo Soldiers) in support of Colonel Roosevelt's Rough Riders at the Battle of San Juan Hill in 1898. (Author's collection.)

After the Confederates crossed into West Virginia, a force remained in the Washington County area to clean up in the wake of the retreat and pursuit. Maj. Gen. William "Baldy" Smith, who commanded the Military District of the Susquehanna in Pennsylvania, was placed in charge in this area. Smith was a major general early in the war but fell out of favor after the debacle at Fredericksburg. He was relieved of command in the field army and assigned to the garrison forces in Pennsylvania. Fate dictated that he was not away from the battlefield for long as his forces were actively engaged when Lee invaded that state.

Capt. Alexander C.M. Pennington Jr. commanded Battery M, 2nd US Artillery in the Gettysburg Campaign. Battery M was assigned to the "Horse Artillery"—batteries that were assigned to the fast-moving commands of the cavalry corps. Pennington commanded his battery in several engagements in Washington County during the pursuit of Lee to the Potomac, including Monterey Pass, Smithsburg, Hagerstown, Boonsboro, Williamsport and Falling Waters. Below, the men of Battery M pose for a group photograph near Culpeper, Virginia, about six weeks after their exhausting experience chasing the rebels through oceans of Washington County mud.

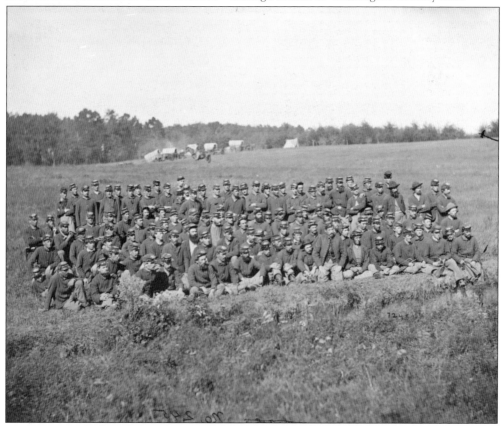

In the summer of 1863, thousands of Marylanders volunteered for service in the US Colored Troops. Joshua Baker was born into slavery in Prince Georges County and relocated with his owner to the farthest western area of Washington County. Baker entered the 39th US Colored Infantry Regiment, fought at Petersburg, and was wounded at Poplar Grove, Virginia. He purchased a home on the east side of Hancock in 1892. In the patriotic fervor of the Spanish-American War, Baker was photographed in the streets of Hancock in July 1898, armed with pistol and sword. (Author's collection.)

Clear Spring resident Lewis Anthony Chase (center) was born into slavery. He enlisted in Company A, 43rd US Colored Infantry in March 1864 and served until the end of the war, attaining the rank of corporal. He earned a 20-day furlough in recognition of being the "neatest soldier in the company." After the war, he settled in central Pennsylvania, led a prosperous life, and became a member of the local Grand Army of the Republic (GAR) post. (Philipsburg Historical Foundation.)

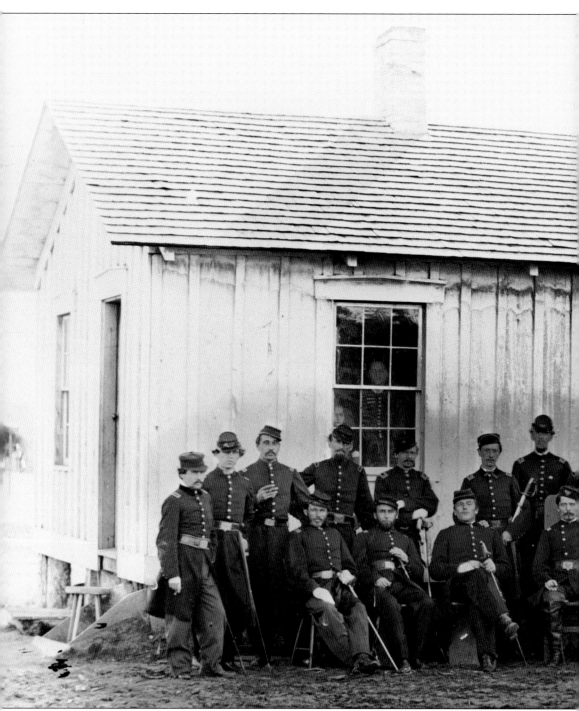

In the summer of 1863, Union recruiting officer Augustus Boernstein (seated center with glasses) was in Hagerstown and heard Robert Moxley's band perform. Moxley's was a brass band consisting of freemen and slaves. Impressed, Boernstein appealed to the members to join the US Colored Troops as a group. They were kept together and formed the 1st Brigade Band, US Colored Troops. The band served in the Siege of Petersburg and in Texas before mustering out in 1866. The bandsmen

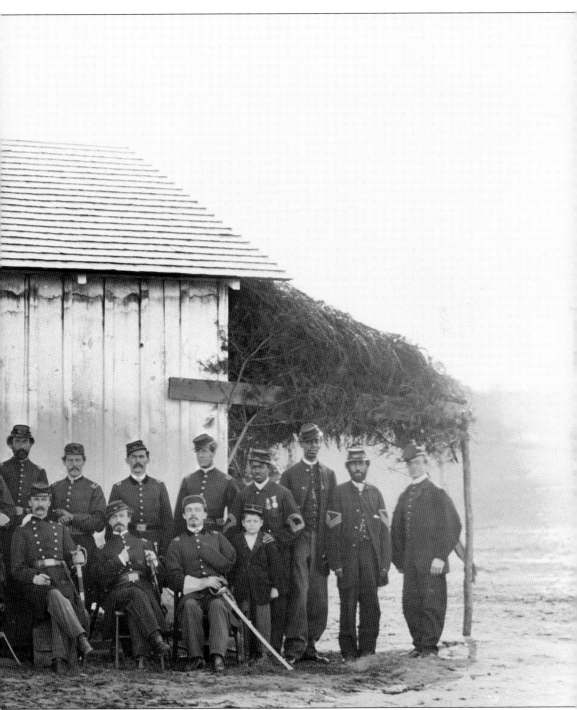

returned to Hagerstown, where they resumed playing as a civilian band. Augustus Boernstein became the commander of the 4th US Colored Infantry. Many of Washington County's African American recruits served in this regiment. This photograph of Boernstein and his officers was taken near Washington, DC, in 1864. Fourth from the right is Sgt. Maj. Christian Fleetwood of Baltimore, who is seen wearing his Medal of Honor.

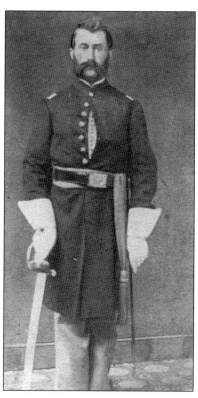

Peter Mayberry was a Hagerstown resident and relative of the Mobley family. Midway through the war, he was commissioned as a lieutenant in the 3rd Maryland Potomac Home Brigade Infantry Regiment. After the war, he served as sheriff of Washington County. (Justin Mayhue.)

After spending a year as a prisoner of the Lincoln administration, Charles MacGill elected to follow Lee's army into Virginia after the Gettysburg Campaign. According to family reports, he received a commission as an army surgeon directly from Confederate president Jefferson Davis. Little is known of his military service, but it is known that MacGill worked in the field hospitals in the aftermath of the Battle of Spotsylvania and was paroled at Lynchburg at the end of the war. (Author's collection.)

The local road network regularly saw troops marching through the area. The Harpers Ferry Road was the most direct route between that town and Hagerstown. Here, the road parallels Antietam Creek in the area of a hamlet known as Antietam Furnace. (Stephen Recker.)

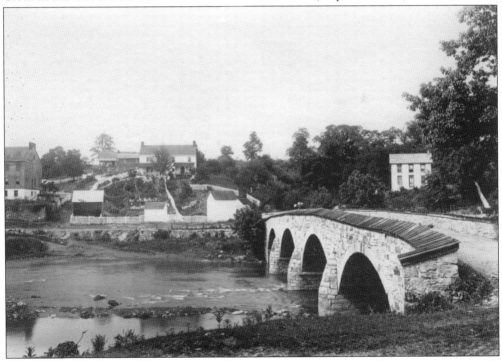

The hamlet of Antietam Village was a small commercial center serving the south county area. It consisted of little more than a furnace and several homes. When the Union cavalry escaped the siege of Harpers Ferry in September 1862, it traveled through here on the Harpers Ferry Road on its way to safety in Pennsylvania. (Stephen Recker.)

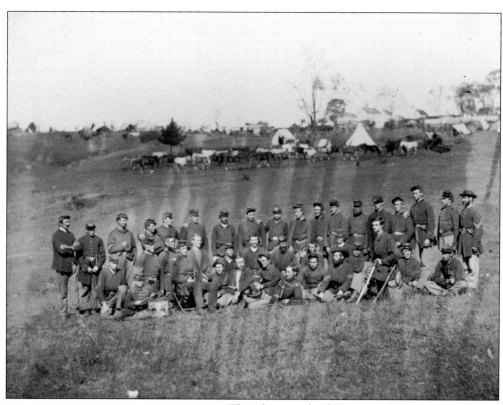

This photograph of Company G, 93rd New York Infantry is representative of the typical Union soldiers who fought their way through Washington County in 1862 and 1863. The 93rd was headquarters guard of the Army of the Potomac from May 1862 to April 1864, serving the headquarters of Generals McClellan, Pope, Burnside, Hooker, and Meade. The men are shown here at Bealeton, Virginia, about three weeks after they participated in the pursuit of Lee's army across Washington County after the Battle of Gettysburg. Lt. Robert L. Gray is seated on the crate in the right center of this photograph.

Robert Liston Gray served as the quartermaster of the 93rd New York Infantry during the Antietam Campaign. This regiment was fortunate in its assignment as General McClellan's headquarters guard. It missed the carnage of the bloodiest single-day battle in American military history. The regiment was present in early October when President Lincoln visited the army and the battlefield. Gray later transferred to Company G as a line officer. He fell in the Battle of the Wilderness. (New York State Military Museum.)

Rev. Henry Edwards was the pastor of St. John's Episcopal Church in Hagerstown. A "Union man," he ran into difficulties with his flock, which included many of Hagerstown's most vocal Confederate sympathizers. Reverend Edwards was commissioned by President Lincoln to serve as the chaplain of the US Army hospitals in Hagerstown. After the war, he served other parishes in the county and as commander of Hagerstown's Grand Army of the Republic post. (Author's collection.)

This photograph, taken around 1864, gives the viewer the perspective Confederate cavalrymen had during the July 6, 1863, Battle of Hagerstown when they flanked Federals charging north on Potomac Street from Public Square. This photograph was taken from the vicinity of today's Hagerstown Post Office, with a view looking east on West Franklin Street. Picture at the top of the hill, by city hall, Capt. Ulrich Dahlgren appears on horseback in the intersection, leading a dismounted force of men from the 18th Pennsylvania Cavalry. The Union troops were charging through the intersection, advancing from the viewer's right to left. Dahlgren was wounded in the foot in this attack. (Stephen Recker.)

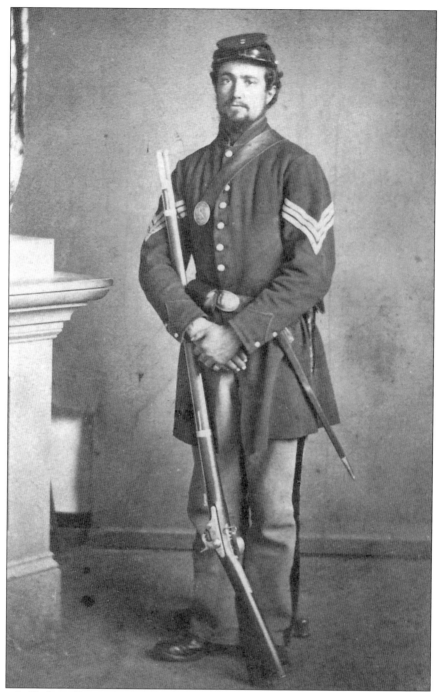

George C. Updegraff was part of a family of hatters on West Washington Street in Hagerstown when he enlisted in Company A, 7th Maryland Infantry in August 1862. When the company formed in Baltimore, he was made sergeant. Updegraff served in the regiment until being sent home to Hagerstown due to illness in April 1863. He never returned, succumbing to consumption (tuberculosis) on August 27, 1863. Disease claimed two out of every three soldiers who died in the service. (Justin Mayhue.)

Four

WEARY OF WAR
1864–1865

Adam Benjamin Martin was a Mexican War veteran from Smithsburg. In the summer of 1862, he joined Company H, 6th Maryland Volunteers. He was made captain of the company and was wounded at Mine Run, Virginia, in November 1863. At the Battle of the Wilderness, Martin was leading his company in a charge against a force of rebel infantry when he received two serious wounds. He died during surgery the next day. For years, his portrait hung in the Smithsburg town hall, and a memorial window at St. Paul's Lutheran Church was dedicated in his memory. (Author's collection.)

THIS IS THE D

As the war dragged on, so did life. Commerce continued, as did society. Here, in a very rare indoor photograph, one of the local churches appears to be conducting an Easter service in the Hagerstown Lyceum. Constructed in the 1840s, the lyceum was a debating and performance hall that had been used as an army hospital in 1862. Musician Edwin Rice of the 13th Massachusetts

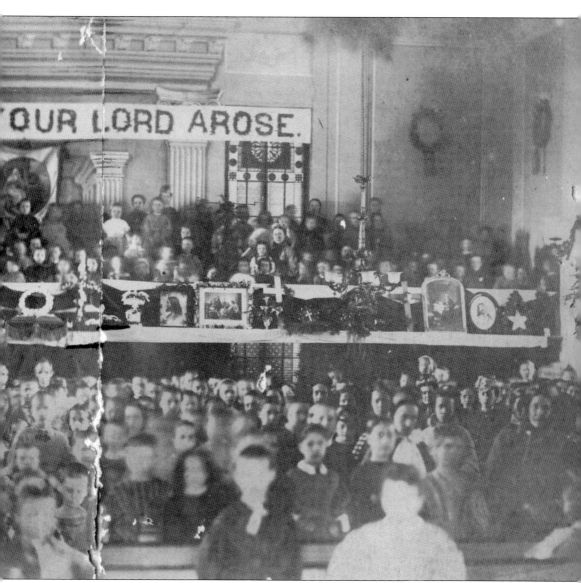

OUR LORD AROSE.

Regimental Band wrote home in 1861 that he attended a performance of his regiment's glee club here and was impressed with the large fresco in the back of the assembly hall. (Washington County Historical Society.)

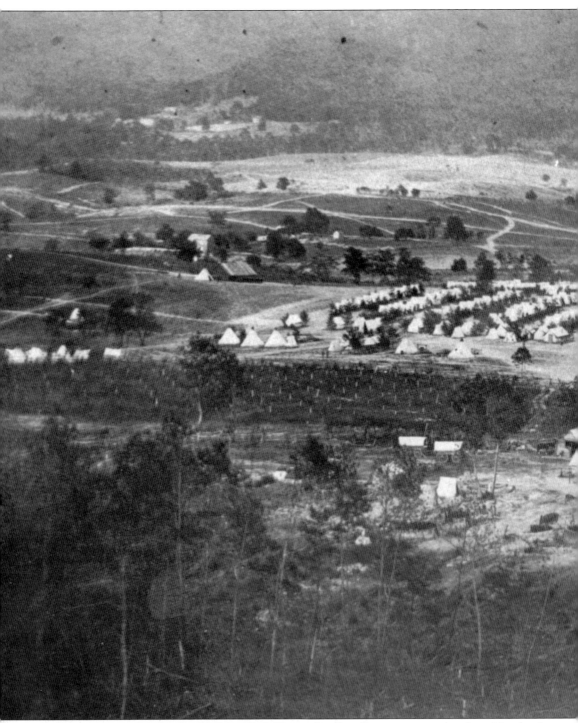

In the summer of 1864, the 6th New York Heavy Artillery Regiment encamped on Maryland Heights. The area on the back slopes of the cliffs overlooking Harpers Ferry was a constant military camp through most of the war. Attempts to dislodge defenders in early July delayed Jubal Early's advance on Washington during the Monocacy Campaign. Taken from the eastern bastions of

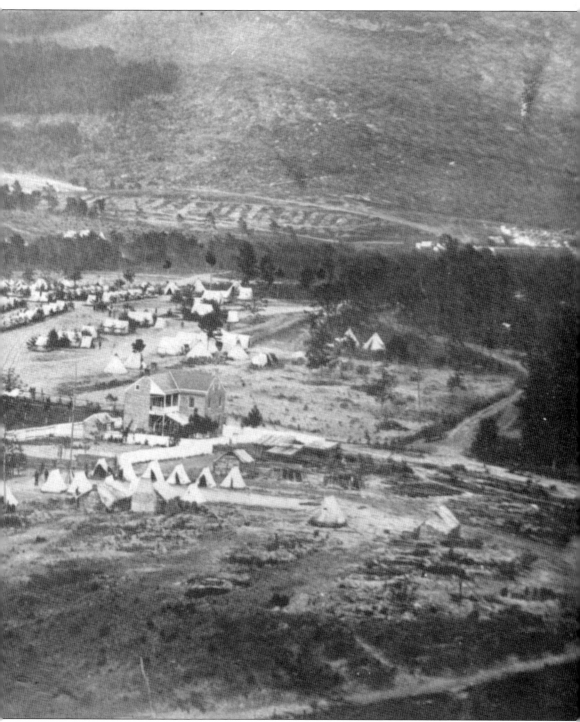

Fort Duncan, with a view looking northeast toward Elk Ridge, this photograph shows the camp of the 6th New York. Fort Duncan and the lands in the foreground are now part of the Chesapeake & Ohio Canal National Historical Park. The brick house survives today and can be seen from Pleasantville Road. (New York State Military Museum.)

John C. English was born in Fort Duncan on Christmas Day 1864. His father was an army engineer, and his wife lived at the fort. John's father soon was reassigned elsewhere, and his mother died when he was an infant. Although his father contacted local residents who were caring for John, stating his intent to reunite his family, he was never heard from again. Perhaps the war claimed his life as well. John and his elder brother were raised by a couple in Rohrersville. After a stint in the Army during the Spanish-American War, John returned to the area and lived in Rohrersville and Hagerstown. (Author's collection.)

On July 4, 1864, the third and final Confederate invasion north of the Potomac River commenced at Boteler's Ford, located just south of Shepherdstown and Bridgeport. Here, a small army under the command of Gen. Jubal Early crossed into Maryland.

On July 5, a cavalry brigade under Gen. John McCausland parted from Early's main force at Sharpsburg and marched north to Hagerstown. In the vanguard of McCausland's horsemen was 16-year-old Samuel Milford Schindel. A native of Hagerstown, Schindel knew the local roads and countryside and served as a guide and scout for McCausland's force when it entered Hagerstown on July 6. (Author's collection.)

A squad from the 18th Pennsylvania Cavalry entered Hagerstown from Funkstown and was surprised by the rebels as it passed St. John's Lutheran Church. As his detail surrendered, Lt. Thomas Torrence attempted to fight but was wounded twice. He fled to a nearby home. Postwar, he was a traveling salesman, and whenever in Hagerstown, he would make a call on the family who saved him from falling into rebel hands. (Author's collection.)

Hdqr Cav Brig.
Hagerstown Md.
July 6 1864.

Genl Order
No. —

I In accordance with the instructions of Lt. Genl. Early a levy of $20000. twenty thousand dollars. is made upon the inhabitants of this City. The space of 3 hours is allowed for the payment of this sum.

II A requisition is also made for all Govt. Stores.

III The following Articles will also be furnished from the merchandise now in the hands of citizens or

General McCausland handed City Councilman Matthew Barber a demand for $20,000 and 1,500 complete sets of men's clothing. If the city did not comply, it would be burned. Barber consulted former congressman James D. Roman, who developed a plan to pay the ransom, leveraging cash from the local banks against assurances signed by the city council and prominent citizens that the town would petition the Maryland legislature for taxation and bonding authority to repay the banks. The Confederates agreed to accept all the clothing that could be collected in the time allotted to provide the money. By the end of the day, $20,000 in various forms of currency was turned over to McCausland's quartermasters. The rebels left around midnight, marching east to catch up with Early's main army near Frederick. (Author's collection.)

merchants. Viz. 1500 suits of clothes, 1500 hats, 1500 prs. shoes or boots, 1500 shirts, 1500 prs. drawers, 1500 prs. socks. (2) Four hours allowed for this collection.

IV The mayor & city council are held responsible for the execution of this order, & in case of non compliance, the usual penalty will be enforced upon the city.

Jno McCausland
Brig. Genl. Comd.

An image of the final copy of the ransom and a receipt for the materials turned over to the rebels that was given to the town appears in the author's Arcadia Publishing book *Hagerstown in the Civil War*. This second ransom note was donated to the Library of Congress in 1906 by the grandson of Congressman Roman. It is kept in the Jubal Early Papers. The author deduces that this ransom note was likely the one handed to Councilman Barber. The logical conclusion is that Barber may have given it to Roman in his efforts to get him to help satisfy the Confederates, and Roman kept it. Although this conclusion is logical, this is speculation on the author's part and a "chain of custody" does not exist. (Author's collection.)

Responsibility for collecting the payment was assigned to Capt. John Crawford Van Fossen. It was Van Fossen who prepared and signed the final statement and receipt provided to the town for the cash and clothing received. A native of Winchester, Virginia, he was a leader in the development of public education in Frederick County, Virginia. Van Fossen Street in Winchester is named for him. (Author's collection.)

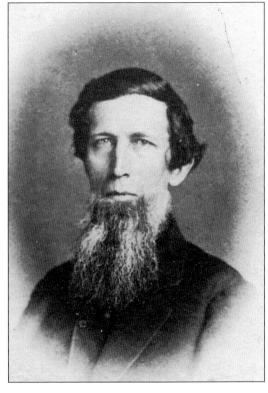

Since Mayor John Cook was a merchant and had to hustle his inventory out of town before the Confederates arrived, the Hagerstown City Council had to appoint a mayor pro tem to act in his place for the duration of the emergency. When it met to consider ways of addressing Confederate demands, the council elected Councilman Thomas Boultt (pictured) to serve in that role. A jeweler by trade, Boultt additionally served the community after the war as one of the first directors of the Antietam National Cemetery. (Lisa Saarni, descendant.)

I, Mathew S. Barber of Hagerstown Washington County and State of Maryland, do solemnly swear that I will support, protect and defend the constitution and government of the United States against all enemies whether domestic or foreign, and that I will bear true faith, allegiance and loyalty to the same, any ordinance resolution a law of any State, convention or legislature of any State to the contrary notwithstanding, and further that I do this a full determination pledge and purpose without any mental reservation or evasion whatsoever, and further that I will well and faithfully perform all the duties which may be required of me by law. So help me God

Sworn before me the Subscriber a Justice of the Peace of the State of Maryland in and for said County, This 16th day of May 1864

M. S. Barber

Wm M Tice J.P

In areas that were regularly monitored and occupied by the Union army through most of the war, residents were expected to take an oath of allegiance to the United States. Those who resisted were monitored for Southern sympathies and collusion. Some were banished to the South. Hagerstown city councilman Matthew Barber provided his oath of allegiance six weeks prior to his involvement in the ransom of Hagerstown. As the city treasurer, he was the lead negotiator for the community as it attempted to meet General McCausland's demands. (Author's collection.)

With the damage being intentionally inflicted on the civilian populace in the Shenandoah Valley, Southerners retaliated during Early's raid on Washington. In addition to the ransoms demanded of several towns, the respect of private property that characterized previous campaigns in 1862 and 1863 was not exhibited in 1864. Here, a newspaper artist captured members of Early's cavalry driving livestock captured in Washington and Frederick Counties back into Virginia. (Author's collection.)

The town turned to James Dixon Roman for leadership in the ransom crisis. As a former member of the House of Representatives (1847–1849) and the president of the biggest bank in Washington County, and as someone with misgivings about forcing the seceding states to return to the Union, he was the best choice to turn to in dealing with McCausland's cavalry. (*The Hagerstown Bank at Hagerstown, Maryland: Annals of One Hundred Years, 1807–1907.*)

David Artz was a veteran of Capt. George Shryock's militia company that served in the War of 1812. He was in his 20th year on the board of the Hagerstown Bank in 1864. Artz and the other members of the board had to approve Roman's plan before the bank entered into the agreements with the city council to pay the rebels. Since the bank's interests were protected, the board readily agreed. (*The Hagerstown Bank at Hagerstown, Maryland: Annals of One Hundred Years, 1807–1907.*)

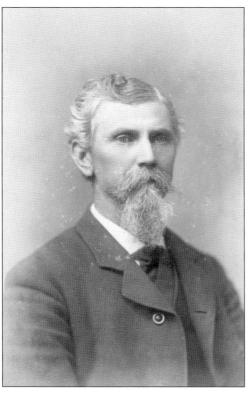

William Thomas Lambie was born and raised in Williamsport. When the war erupted, he was working on a railroad project in Covington, Virginia, and enlisted in the Confederate army's "Alleghany Roughs" Artillery in April 1861. He was promoted to lieutenant and lost an eye at Fredericksburg. By the end of the war, Lambie was a major with Carpenter's Battery. After the war, he moved to California, where he served simultaneously as a member of the Los Angeles Common Council and as the city engineer of Los Angeles. Lambie died in 1900 in the collapse of a tunnel that was under construction. In a "brother vs. brother" story, his brother Edward served as a lieutenant in an unassigned company of US Colored Infantry in 1864. (Graham Pilecki.)

When McCausland's troops entered town, they approached from the Funkstown, Sharpsburg, and Williamsport Roads. Those who approached from the latter entered town on Prospect Street and encountered a company of Maryland cavalry at the corner of Washington and Prospect Streets, by the Rochester House. After a brief fight, the Union troops retreated. This view looking toward the so-called Dry Bridge was taken on South Prospect Street in front of Rochester House. (Stephen Recker.)

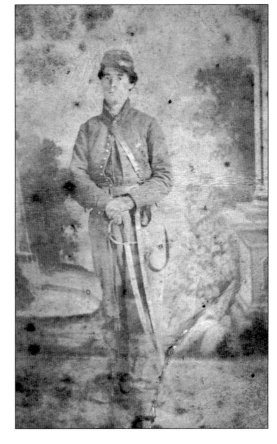

Pvt. Edward Correy enlisted in the 5th New York Cavalry in 1864. When in Hagerstown, he visited the photography studio of Elias Recher and had this image made. The painted-column background is a hallmark of Recher's studio. Many photographs of local residents and visiting soldiers with that backdrop survive today. (Author's collection.)

The City of Hagerstown has been a corporate entity for over 200 years, with the powers and responsibilities not unlike today. When the city council met to consider Congressman Roman's plan to save the city, the meeting was recorded by William Tice, the city clerk. Tice later served as mayor. (Author's collection.)

Andrew Kershner Seyester was a prominent lawyer in Washington County. In 1864, he served as the city attorney for Hagerstown. In 1867, he was a Washington County delegate to the Maryland Constitutional Convention. Known as a gifted orator, Seyester also served as attorney general of Maryland from 1871 to 1875. (Author's collection.)

Henry Mitchell was a resident of Smithsburg. In the war's waning months, Maryland consolidated existing, depleted regiments and recruited additional men to fill the ranks. One of the new regiments of veterans and raw recruits was the 13th Maryland Infantry. Mitchell enlisted on January 24, 1864, achieved the rank of corporal, and was discharged when the regiment was mustered out in June 1865. (Boyd Weber, descendant.)

The Chesapeake & Ohio (C&O) Canal was a lifeline for supplies to Washington, DC. It was a regular target of Confederate attempts to damage it in order to disrupt supply shipments to the nation's capital. This photograph was taken in 1903, showing the canal as it passes in front of Williamsport. The area between the canal and the river is where Confederate wagon trains queued up, waiting for the floodwaters to subside during the retreat from Gettysburg.

The toll of battle in Washington County was forever etched in stone in communities, North and South, as families retrieved their sons for interment in their hometowns. Oliver Cromwell Case of the 8th Connecticut Infantry has the distinction of being "buried" in two places. Initially buried on the Otto farm at Antietam, his remains were recovered by his family and reinterred under this grave marker in Simsbury, Connecticut. Apparently his temporary marker remained on the battlefield. When the dead were reinterred in the National Cemetery in 1866, another soldier was mistakenly identified as Case, and the government marker in the National Cemetery erroneously bears his name. (John Banks.)

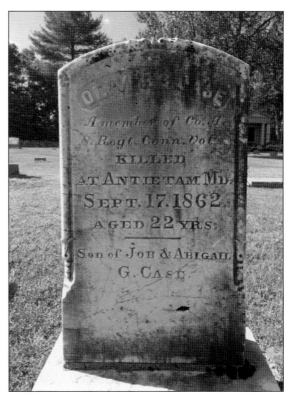

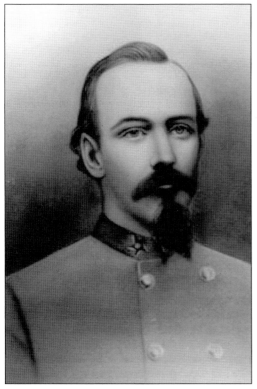

Hancock resident James Breathed was a physician. In 1861, he cast his lot with the South, entering as a cavalry private before transferring to J.E.B. Stuart's horse artillery. Breathed rose through the ranks and arguably became the most successful artillery battalion commander in the war on either side. Haunted by the horrors of his experiences, he returned to Hancock and resumed medicine but passed away in 1870 at age 32. (Author's collection.)

Mary Coon was born into slavery on the eastern shore of Maryland. When her mistress married Col. Frisby Tilghman and moved to Rockland Plantation in Tilghmanton, Mary came with her. She obtained her freedom in the 1850s, married a traveling freeman blacksmith, and settled in Hagerstown, where she had several children. Her son Nelson Coon served in the US Colored Troops as a member of the 1st Brigade Band, known locally as "Moxley's band." Moxley's band existed before the war, consisting of slaves and freemen. In 1863, the band was recruited as a group to serve as a military band for the newly forming colored troops. (Western Maryland Room, WCFL.)

History is never simple. Otho Nesbitt was a Clear Spring slave owner, yet a strong Union man. When Maryland abolished slavery in late 1864, he could not afford to pay his former slaves to continue working his farm. But winter was coming and, if they chose, he offered to allow the newly freed citizens to stay on with him doing their same jobs for the same terms (room and board) until spring. The offer was readily accepted. (Clear Spring District Historical Association.)

Five

150 YEARS OF MEMORY AND COMMEMORATION
1865–2015

As the war wound down, regiments needed to be recruited to replace those being disbanded due to the expiration of three-year enlistments. Samuel Roof of Cavetown joined the 199th Pennsylvania Infantry in September 1864 and served nine months. He returned to his wife, Cassandra, and they lived the remainder of their lives in the Clear Spring and Indian Springs communities in the western part of Washington County. (Paul Gantz, descendant.)

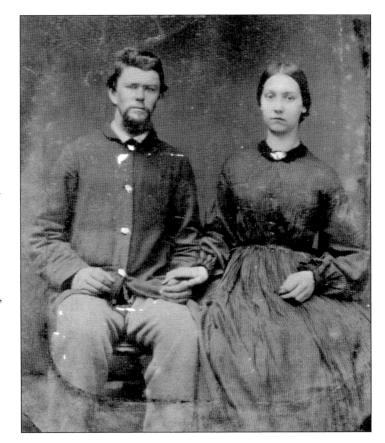

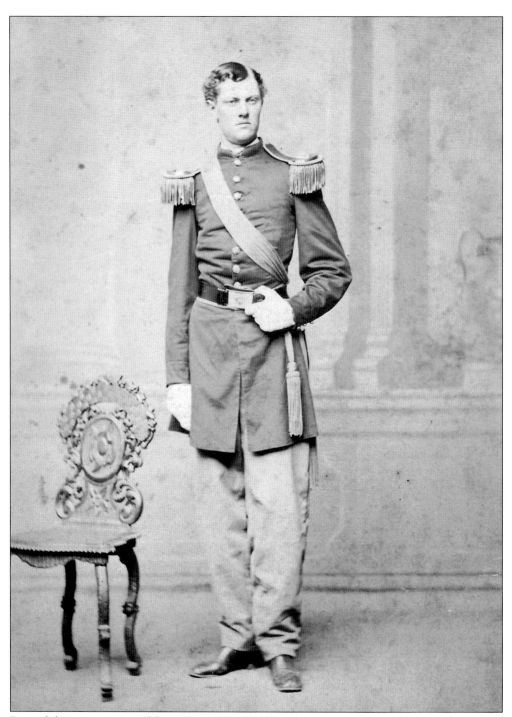

Peace did not mean no need for an army. In 1867, Sharpsburg resident James Anderson Buchanan was appointed a lieutenant in the army, serving until he retired in 1906 with the rank of brigadier general. He served at several posts on the frontier and in Puerto Rico and the Philippines during the Spanish-American War. Fort Buchanan near San Juan, Puerto Rico, is named in his honor. (Washington County Historical Society.)

DISCHARGE.

Cloverdale Botetourt Co Va
April 29th 1865
The bearer Private J. R. Stonebraker
Co "C" 1st Md Cav having done his duty
faithfully to the present time is permit-
ted to go where he pleases until called for
G Worsey
Lt. Col. Comdg 1st Md Cav.

The 1st Maryland Cavalry (CS) escaped Appomattox but disbanded later in the month. When Funkstown resident Joseph Stonebraker started for home, he received this pass from the regiment's commander, Lt. Col. Gustavus Dorsey. He kept the document the rest of his life and was so moved by it that he had it its entire contents inscribed on his grave marker. Late in life, Stonebraker published two books about his experiences in the war. (A *Rebel of '61* by Joseph R. Stonebraker.)

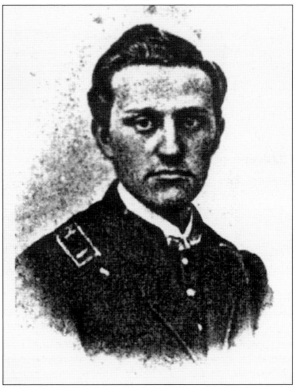

In November 1865, Lt. John Rigdon King of the 6th Maryland Infantry led the effort to form one of the first Union veterans' organizations in the United States. Meeting in the Washington County Courthouse, the men formed the Washington County Soldiers' Union. This organization later became Reno Post No. 4 of the Grand Army of the Republic. King was wounded three times during the war. (Author's collection.)

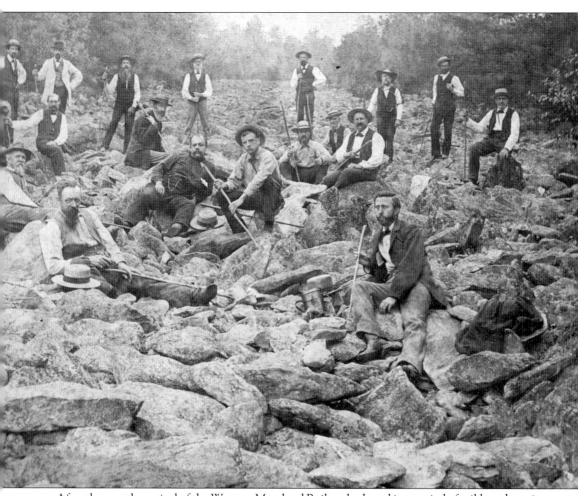

After the war, the arrival of the Western Maryland Railroad ushered in a period of rail-based tourism to Washington County. Urbanites from Baltimore would take the train to Penmar, Hagerstown, and points west for vacations and to escape the heat of the city. The region around Cascade and Penmar developed into a mountain resort area, with guesthouses, hotels, a dance hall, and other forms of entertainment. Here, tourists sit in a geological area known as "the Devil's Racecourse" below Penmar. (Stephen Recker.)

As life returned to "normal," great economic shifts occurred in the nation. With its relatively small slave population, those changes were not as dramatic in Washington County. But forced labor was no longer part of the equation. Captured by Hagerstown photographer Elias Recher around 1869, this image depicts a nanny named Nancy who earned her way in life caring for Mary and Sandra Giles, twin daughters of Walter and Mary Louisa Kielhofer Giles. (Byron Family Papers, University of Maryland Libraries.)

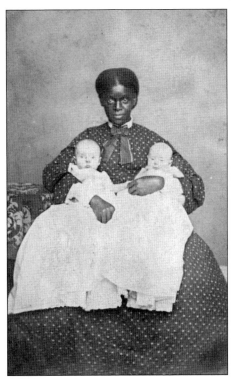

Hagerstown native John Rigdon King (left) advanced through the ranks of the Grand Army of the Republic to serve in its highest post—commander in chief—in 1905. A lifelong advocate for veterans' issues, he served to the last, dying of a heart attack in the halls of the US Capitol in 1934. He is pictured here in 1932 in Springfield, Illinois, with then current commander-in-chief James Jewel of Colorado. (Herbert Wells Fay Collection, Abraham Lincoln Presidential Library and Museum.)

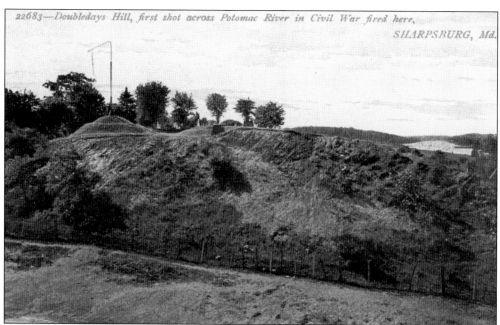

One of the first events of the war in Washington County was the investment of the hill adjacent to Riverview Cemetery in Williamsport by Capt. Abner Doubleday. Doubleday was part of the Union garrison at Fort Sumter, and when he arrived in the county weeks later, he was given a hero's welcome. The site became "Doubleday Hill" and has been marked with three commemorative cannons and interpretive markers. (Author's collection.)

Relations between Sharpsburg residents and the government have been testy ever since the battle in 1862. The government's failure to compensate property owners sufficiently for damages left hard feelings. As Antietam National Battlefield developed, conflicts over property rights surfaced. Relations hit their worst in 1912, when park superintendent Charles Adams, a Smithsburg native, was murdered near Burnside's Bridge by an area resident whose court case was damaged by Adams's testimony. (Stephen Recker.)

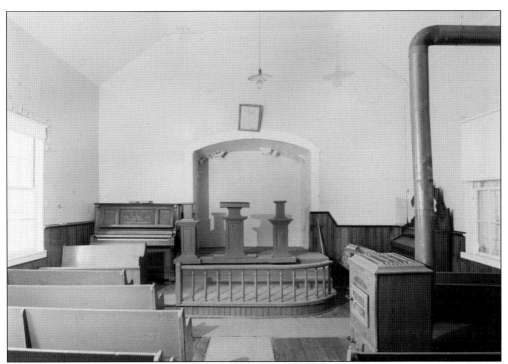

A massive effort was moved forward to provide for the physical and educational needs of recently freed slaves. Schools were opened in several locations in the county. In 1866, Tolson's Chapel was constructed on land donated by a local African American couple on High Street in Sharpsburg. Beginning in 1868, the Freedmen's Bureau operated the American Union School here. Its first teacher was an African American from Baltimore named Ezra Johnson.

The building was used for a school for African American children until 1899, when the Sharpsburg Colored School opened nearby. The Tolson's Chapel African Methodist Episcopal (AME) Church survived until the late 20th century, then fell into disrepair. The building was purchased by Save Historic Antietam Foundation in 2002 and stabilized. In 2008, the Friends of Tolson's Chapel assumed ownership, and restoration was recently completed.

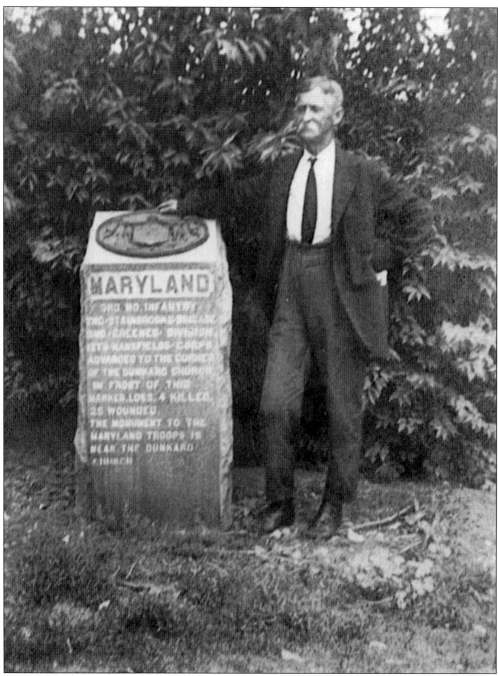

Oliver Thomas "O.T." Reilly was a five-year-old child in Keedysville during the Battle of Antietam. He watched the fighting in the distance from a hill near Keedysville. The battle set his destiny in motion, and, as a Sharpsburg resident in his adulthood, Reilly spent years collecting and selling artifacts and acting as the first informal tour guide at the battlefield. In 1906, he published an authoritative guide to the battle. When he served as a guide for veterans, he pried them for as much first-person information he could and became the most authoritative expert on the battle. Here, Reilly poses next to the monument for the Union's 3rd Maryland Infantry. (Stephen Recker.)

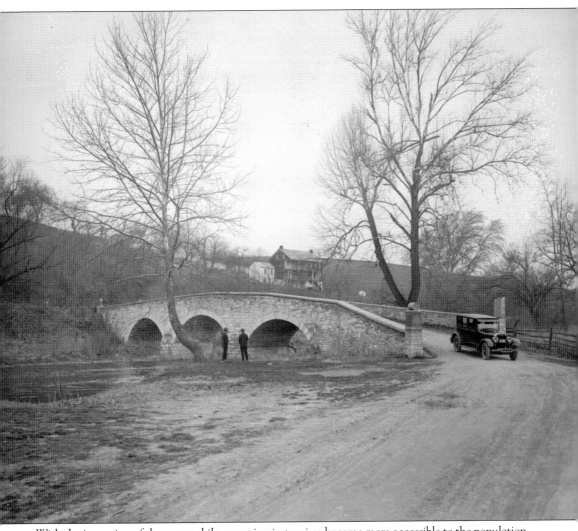

With the invention of the automobile, engaging in tourism became more accessible to the population. Advertisements reflected this. In this image that was produced for advertising purposes in the early 1920s, a Ford automobile is shown on the east side of Burnside's Bridge. Traffic remained open on the bridge well into the 20th century. The house in the background did not exist during the battle. The area to the left is known as "Georgians' Overlook," which is where two regiments of Georgia infantry held back waves of Union troops attempting to force their way across the bridge. With all of the attacking troops funneled onto the bridge, the Southerners maximized the effectiveness of their fire by concentrating on the immediate area of the bridge.

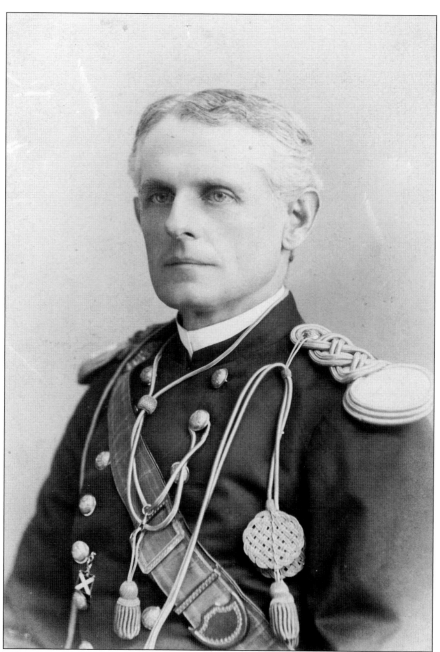

One of the most remarkable results of the Civil War, which, in part, defines Americans, was the rapidity with which former Confederates took up the defense of the reunited nation, along with the fact they were permitted to do so. In 1880, Confederate veteran Henry Kyd Douglas formed the Hagerstown Light Infantry, a company of infantry for service in the newly reorganizing Maryland National Guard. After several years, Douglas was promoted to colonel of the 1st Infantry Regiment, Maryland National Guard, and is pictured here in his colonel's uniform. In his honor, the company was renamed the Douglas Guards. Douglas served as adjutant general of the Maryland National Guard from 1892 to 1896. He was also considered for a commission in the US Volunteers during the Spanish-American War. (Washington County Historical Society.)

Two of Hagerstown's postwar mayors were Civil War veterans. Dr. Charles E.S. McKee served as the surgeon of the 3rd Maryland Potomac Home Brigade Infantry Regiment (Union). After the war, he practiced briefly in Garrett County. He soon returned to Hagerstown and left medicine to open a hardware store on North Potomac Street, a few doors from city hall. McKee served as Hagerstown's mayor from 1874 to 1876. (Washington County Historical Society.)

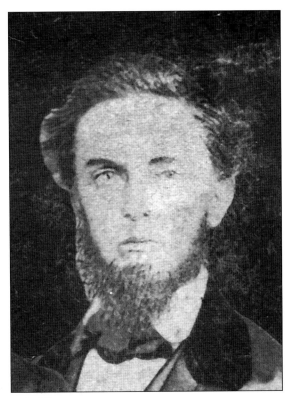

The other was Lewis Delamarter. A native of Binghamton, New York, he served in the Pennsylvania Volunteers before transferring to the 6th US Cavalry. He was actively involved in the Union army's pursuit of Lee's retreating army through Washington County following Gettysburg. Delamarter settled in Hagerstown and operated a lumber company. He was elected mayor in 1888 and served until 1890. (Author's collection.)

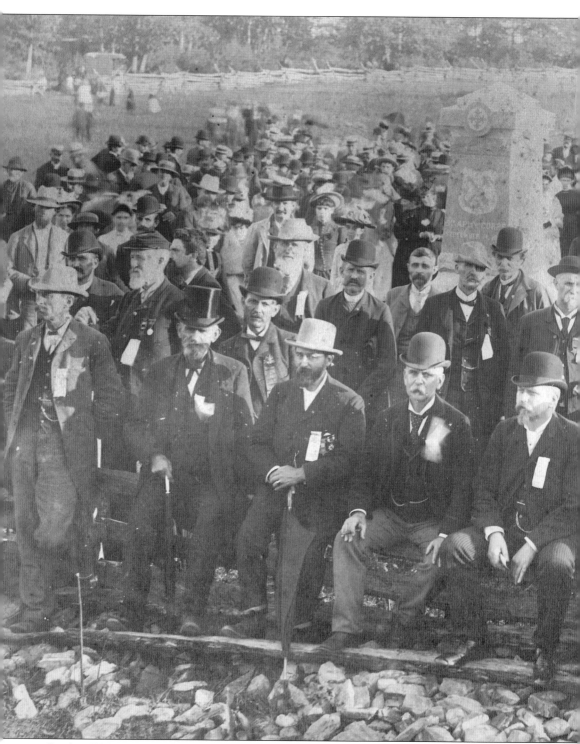

By the 1880s, veterans began to commemorate the honor and sacrifice of their comrades in greater numbers. As time and age distanced them from the horrors and pain of their service, bank accounts fattened and the treasuries of fast-growing veterans' organizations allowed veterans to

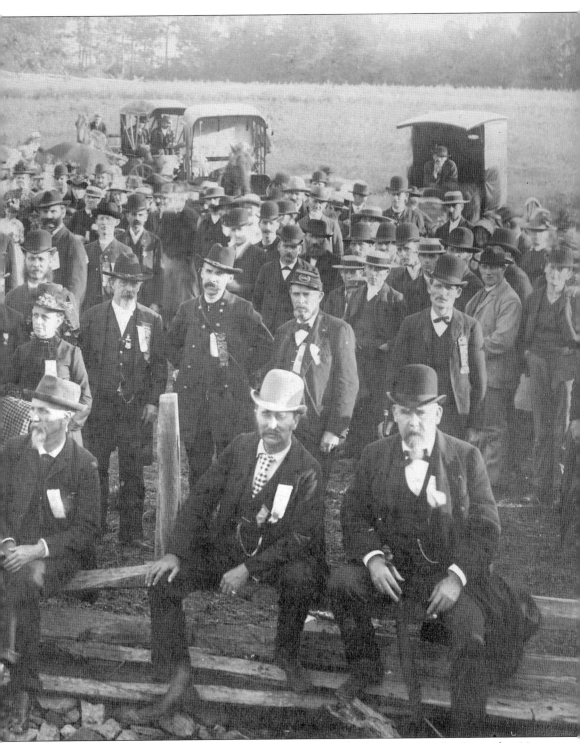

buy land or easements and erect granite memorials designed to last centuries. On September 14, 1889, veterans of the 9th Army Corps unveil the monument to their fallen commander, Maj. Gen. Jesse Reno, where he fell at Fox's Gap. (Kevin Boyer.)

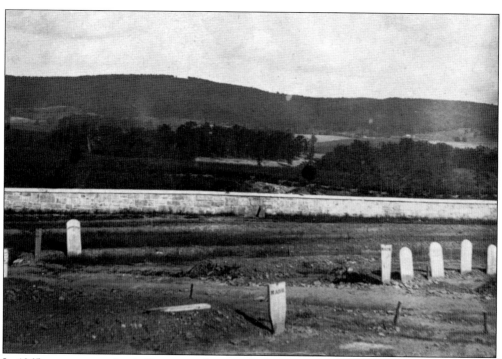

In 1865, state senator Lewis Firey gained approval of a bill in the Maryland legislature to create a cemetery for the war dead buried in Western Maryland, most of whom fell at Antietam and South Mountain. By the time the cemetery was constructed and dedicated in 1867, it was determined that only Union soldiers would be interred there. This image may be the earliest known photograph of Antietam National Cemetery. The view is looking east toward Fox's Gap, showing the beginnings of the Massachusetts section of the cemetery on the left and the Michigan section on the right. The area to the background will become a section for unknown soldiers.

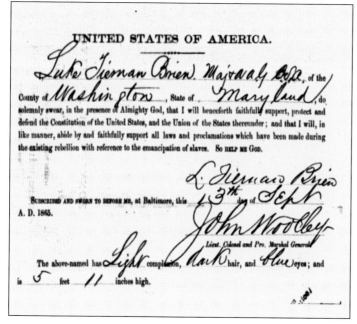

The Confederates who surrendered at Appomattox were provided individual paroles and were allowed to return home. Those who surrendered individually were subject to local variations. Maj. Luke T. Brien, formerly of Hagerstown, served on the staff of Jeb Stuart. He signed this parole when he returned to Maryland, which included specific references to abiding by new laws related to the abolition of slavery. (National Archives.)

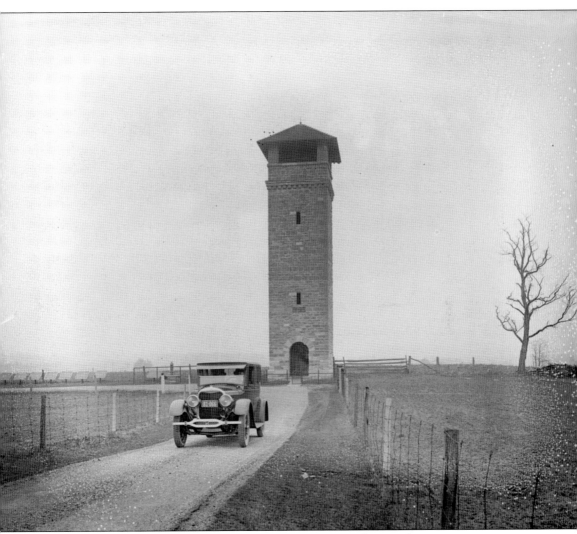

Antietam generated curiosity before the battle was even over, and visitors began arriving as soon as several days afterward. Over the years, as monuments, markers, and other features developed and guides became available to give tours, the popularity of visiting Antietam and other battlefields increased. Tourists are pictured in 1925 driving southbound on Richardson Avenue with the Sunken Road observation tower and the Gen. Israel Richardson "mortuary cannon" monument in the background.

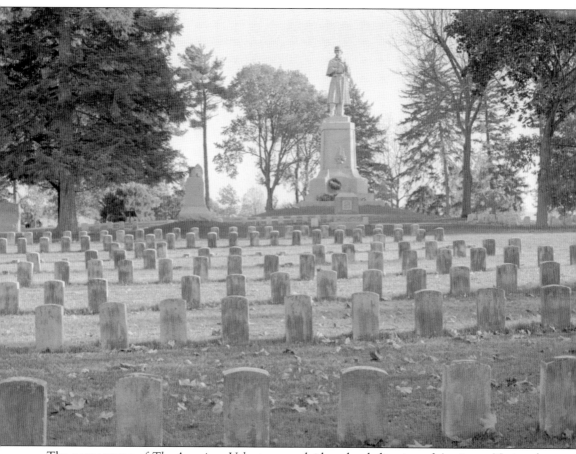

The cornerstone of *The American Volunteer* was laid at the dedication of Antietam National Cemetery in 1867. It was shipped in two pieces to Washington, DC, for transportation to Sharpsburg via the C&O Canal and then moved on rollers to the cemetery. The 21.5-foot-tall soldier, mounted on a 23-foot-tall base, was dedicated in impressive ceremonies on September 17, 1880.

This image, taken from a c. 1875 stereocard, captures a bystander with the statue, providing context to its massive size. Nicknamed "Old Simon" after the veteran who served as a model for the work, the monument weighs approximately 25 tons. The statue was created in Rhode Island.

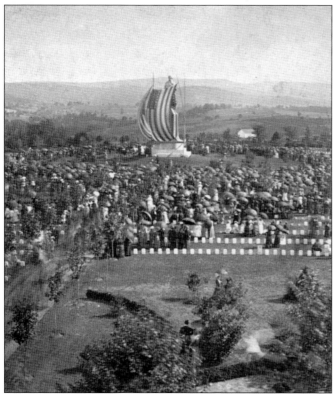

Designed by James G. Batterson of Hartford, Connecticut, and sculpted by James Pollette of Westerly, Rhode Island, at a cost of over $32,000, the "Private Soldier" first stood at the gateway of the Centennial Exposition in Philadelphia in 1876. It was disassembled again for the long journey to Sharpsburg. Old Simon was unveiled at Antietam on the 18th anniversary of the battle, to the approval of a large crowd. This photograph of the festivities was captured from the roof of the caretaker's cottage at the cemetery's entry gate. (Stephen Recker.)

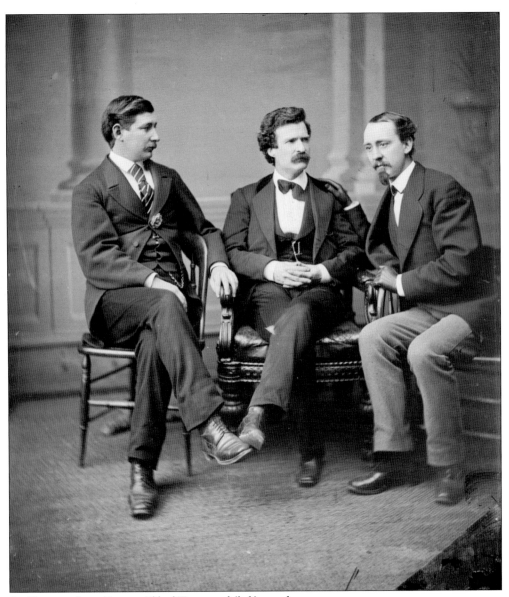

At 20 years of age, George Alfred Townsend (left) was the youngest person to serve as a newspaper war correspondent during the war. He wrote for the *New-York Herald* and published using the pen name Gath. In 1884, he acquired property at the top of South Mountain on the old Crampton's Gap battlefield and developed a summer home on the property. A home, mausoleum, farm buildings, and other improvements were constructed on both sides of the road that passed through the gap. Pictured at center with Townsend is Confederate veteran and rising star in the literary world Samuel L. Clemens. He is better known as Mark Twain. To the right is David Gray, editor of the *Buffalo (NY) Courier*.

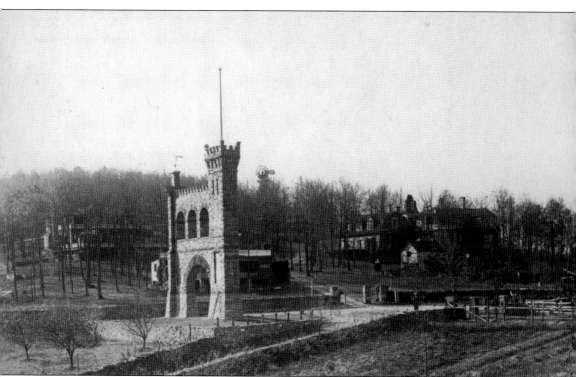

In 1896, Townsend constructed a memorial at Crampton's Gap to honor those who served as war correspondents during the war. The 50-foot-tall memorial contains a list of 157 persons honored by Townsend—yet only 135 of those can be documented as correspondents, and many well-known war correspondents' names did not make it to the memorial. The 22 names that cannot be identified as correspondents are believed to be those of Townsend's friends and financiers of the project. This photograph depicts the monument soon after its completion, with Townsend's Gathland estate in the background. Additional buildings that were part of the complex would have been located to the viewer's right. (Michael Murtaugh.)

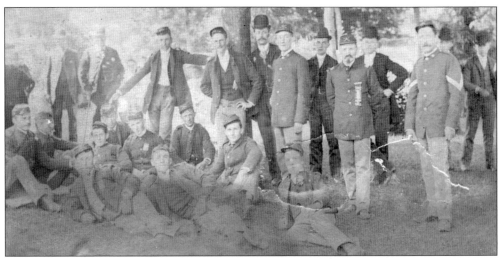

After about 15 years reckoning with the carnage of Civil War, the martial spirit returned to America in the 1880s. In 1880, the Hagerstown Light Infantry was formed for the Maryland National Guard by former Confederate colonel Henry Kyd Douglas. This photograph shows men of the Hagerstown Light Infantry in the late 1880s. The officer in the right center with the large veterans' ribbon on his uniform is Lt. George L. Fisher, a veteran of the Union army. When the unit mobilized in 1898 for service in the Spanish-American War, Fisher served as its captain. (Author's collection.)

Adam Shank and his wife raised their large family in this small house on Water Street in Smithsburg from 1857 to 1866. It is now the home of the Smithsburg Historical Society. Shank served as a sergeant in the 6th Maryland Infantry (Union), and was seriously wounded at the Battle of the Wilderness on May 5, 1864. Stranded on the field at night and unable to move, he sustained additional serious injuries when he was trampled by a squadron of cavalry galloping across the field in the dark. Shank was sent home as an invalid and died a few years later. (Author's collection.)

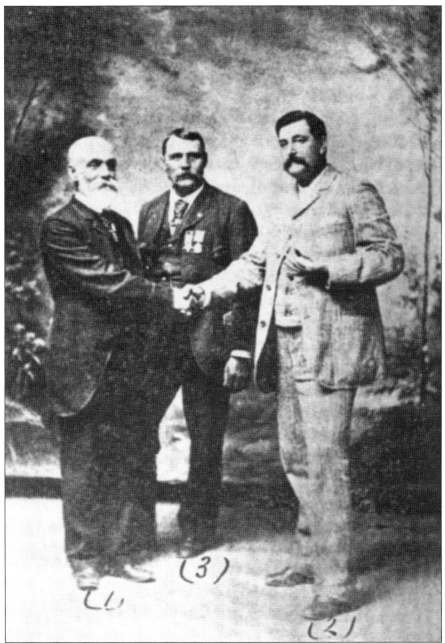

Col. William Fitzcharles Mason McCarty of the 1st Texas Legion (right) lived in Hagerstown in the 1880s. In 1886, he attended the dedication of a monument commemorating the first shot of the Battle of Gettysburg, which was fired by Capt. Marcellus Jones (left) of the 8th Illinois Cavalry. At the ceremony, McCarty chatted with Jones and convinced him that he was the target of Jones's shot. To commemorate the event, Jones arranged for this photograph to be taken of the marksman and his "target." McCarty's Confederate service record is vague and his unit was not at Gettysburg, so his claim cannot be proven. McCarty was either the most important yet unsung Confederate military veteran to reside in Washington County after the war or the greatest party crasher of 1886. (Author's collection.)

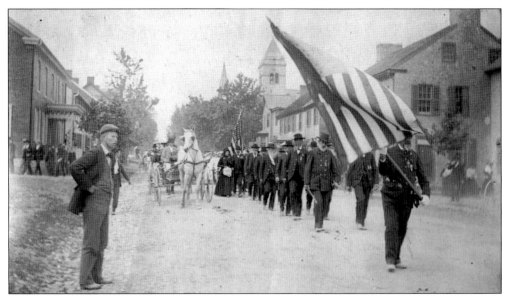

The Grand Army of the Republic grew in popularity in the county, with posts springing up in Hancock, Smithsburg, Hagerstown, Keedysville, and Sharpsburg. Lyon Post No. 31 of Hagerstown served as a home for African American veterans. Here, members of Reno Post No. 4 of Hagerstown, led by post commander Edward Mobley (carrying sword) march along Main Street in Sharpsburg en route to a Memorial Day program at the Antietam National Cemetery, around 1888. (Charles "Jim" Mobley, descendant.)

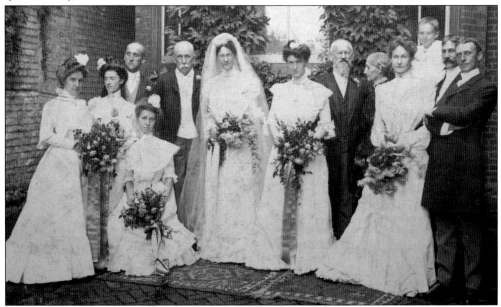

Dr. Augustine S. Mason had been the surgeon in charge of all the Confederate military hospitals around Richmond from 1863 to 1865. He moved to Hagerstown after the war. He is pictured here, right of center, at the 1901 wedding of his daughter Mary Landon Mason. The groom was her 67-year-old widowed uncle by marriage, Confederate general Edward Porter Alexander (left of bride). Family accounts relate that Mary's parents were not pleased. When she passed away in 1946, she was one of the last surviving widows of a Civil War general. (Carroll Hendrickson, descendant.)

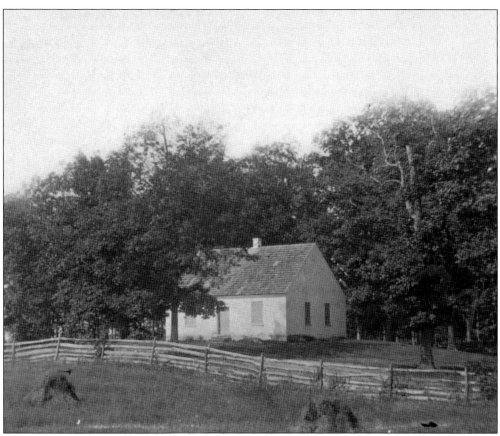

As the war drew to a close, the visual scars of war began to heal. The dead were moved from their random burial sites and interred properly. Crops returned to the fields. Buildings, such as the Dunker Church, that were damaged in the battle were repaired and returned to their previous uses. This photograph of the Dunker Church was captured a few years after the war.

As the president who led America to a quick victory in the Spanish-American War, William McKinley enjoyed widespread support before he was assassinated in September 1901. The nation was thrown into mourning not seen since Lincoln's death in 1865. On October 13, 1903, barely two years after his passing, this monument was dedicated near Burnside's Bridge on the Antietam Battlefield commemorating McKinley's service in the battle.

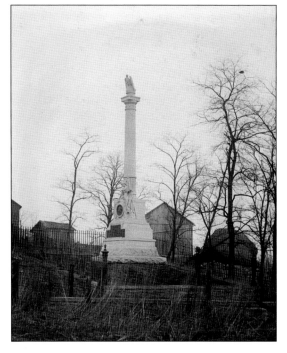

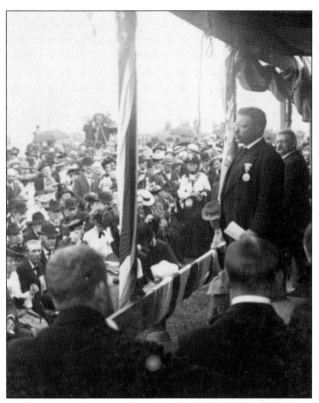

Theodore Roosevelt continued a tradition of presidential treks to Antietam. In 1903, he was invited to give the keynote speech at the dedication of the New Jersey state monument. On the 41st anniversary of the battle, the presidential train pulled into the Cumberland Valley Railroad station on Walnut Street in Hagerstown, where Roosevelt gave a brief speech to an assembled group of local citizens and Union veterans. He then proceeded to the battlefield, where he participated in the day's events. The photograph at left, from a stereocard, shows Roosevelt near the beginning of his speech at the battlefield. While the president spoke, a storm moved in that drenched the audience, as seen below. Fortunately, many anticipated the foul weather and came prepared with umbrellas.

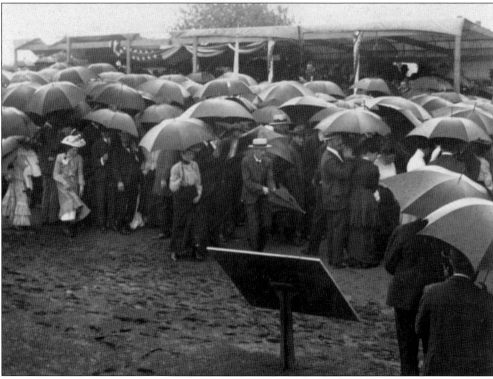

THE HEART OF MARYLAND.

The stage play *The Heart of Maryland* was written by David Belasco. It opened on Broadway in 1895 and ran for 240 performances. Belasco was a frequent visitor to Boonsboro. The play was made into a movie three times—in 1915, 1921, and 1927. Each time, it was filmed in Washington County. A building now part of the Reeders Home in Boonsboro was used as one of the primary homes in the story. This publicity still from the 1921 film depicts Col. Alan Kendrick (portrayed by Crane Wilbur) and Maryland Calvert (portrayed by Catherine Calvert), who rejects him due to his allegiance to the Union in spite of his status as a native Virginian. (Author's collection.)

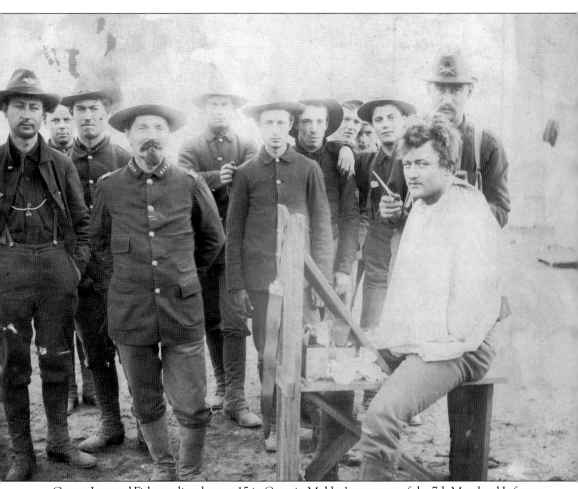

George Leonard Fisher enlisted at age 15 in Captain Mobley's company of the 7th Maryland Infantry. He likely achieved the most impressive military record of any Washington Countian. Captured at Weldon Railroad in 1864, Fisher was held as a prisoner of war until the end of hostilities. He enlisted in the 2nd US Infantry in 1866, rose to sergeant, served in the occupation of the South and fought the Ute Indians. He returned to Hagerstown in 1880 and joined the national guard, rising to captain. Fisher commanded Hagerstown's national guard company during its mobilization in the Spanish-American War. Retired from the guard in 1911, he was called back in 1917–1918 to serve as a drill instructor for the Maryland Home Guard during World War I. Here, Captain Fisher (front) is shown in 1898 with several of his men at the company barber's tent, watching a rather hairy soldier get squared away with his grooming. During the war, as part of the 1st Maryland Regiment, Company B was assigned to (in chronological order) Camp Wilmer (Pimlico Race Course, Baltimore), Fort Monroe (Hampton Roads, Virginia), Camp Meade (Middletown, Pennsylvania), and Camp MacKenzie (Augusta, Georgia). This photograph would have been taken at one of these posts. Fisher was the last Civil War veteran to serve as superintendent of Antietam National Cemetery, from May 1927 until his death on Christmas Eve that year. (Kirk Fisher.)

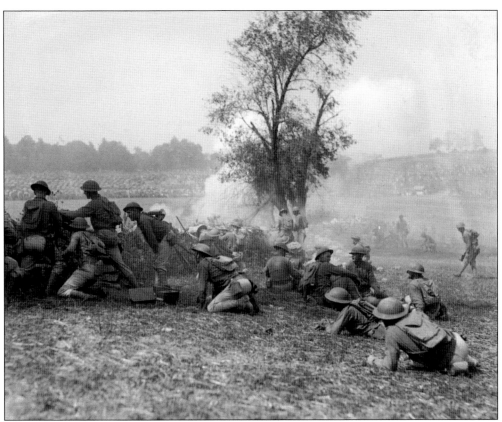

On August 25, 1924, a force of US Marines under Comdt. John Lejeune departed Quantico, Virginia, for the Antietam Battlefield. Lejeune used the national battlefields—including Antietam, Manassas, and Gettysburg—as training grounds for his Marines. It became a major event locally. The highlight of the event was reenactment, of sorts, put on for a crowd of thousands.

The sham battle was staged on September 12, 1924. The use of modern weapons, uniforms, and armor that did not exist 62 years earlier diverged greatly from historical events. Newspapers of the day reported that "there is no effort to reproduce the movements of the original engagement, to be sure, but rather a working out of the tactics which would be employed on such a terrain in modern warfare."

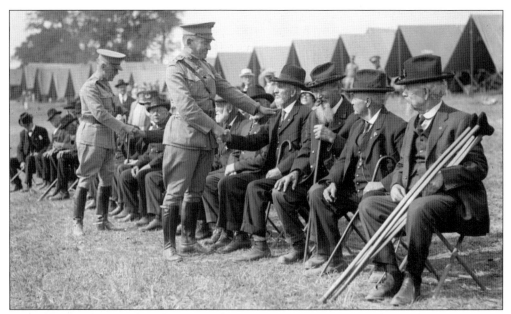

Special honors were paid to the few Civil War veterans remaining in the Washington County community. Here, Gen. Dion Williams (left) and Commandant Lejeune (center) greet members of Reno Post No. 4 of the Grand Army of the Republic. Lejeune is shaking hands with Frederick Foltz, a former county commissioner and Hagerstown city councilman. Wearing glasses, Joshua Thomas, the driver of the first "bookmobile" in the United States, gazes on at center.

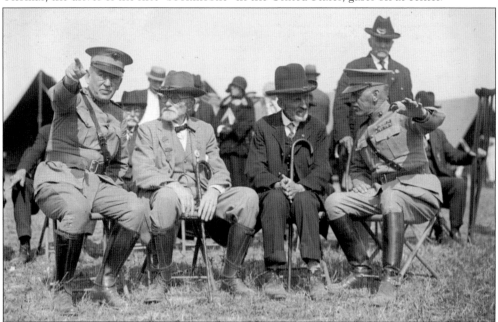

Fewer still were Confederate veterans in the region. They, too, were invited no different than Union veterans. Here, Francis Jones of nearby Charles Town, West Virginia, sits with Frederick Foltz as the generals describe the tactical exercises they are observing. This very much symbolizes the reunion of the nation. Commandant Lejeune's father, Capt. Ovide Lejeune, commanded a company in the 1st Louisiana Cavalry in the rebel army.

Seventeen-year-old Williamsport native Thomas Calvin Rowe enlisted in the 12th Maryland Infantry in July 1864 and served until the unit mustered out in November. He remained in the Williamsport area, buying the 148-acre Daniel Donnelly farm at the Falling Waters battlefield in 1887. Rowe was the last surviving member of Reno Post of the GAR. When he passed away in 1936 at age 89, he was one of only three or four surviving Civil War veterans in the county. (Author's collection.)

The 75th anniversary drew national attention and presented an opportunity for economic development during the Great Depression. Scores of special events were held throughout the county— not all tied to the theme of the Civil War. A historical pageant of Washington County history was held at the fairgrounds in Hagerstown. A "Miss Antietam" contest was held. Owners of historic homes throughout the county threw their doors open to visitors for the duration of the observance. Souvenirs were produced and sold. This 64-page event program, available for 25¢, provided event-goers a good guide to all of the events from September 4 until the conclusion of the observance on September 17. (Author's collection.)

In September 1937, a national two-week-long extravaganza was held to mark the 75th anniversary of the Battles of South Mountain and Antietam. Approximately 50 surviving veterans returned for the observances. The event culminated in a battle reenactment attended by Pres. Franklin Roosevelt, who addressed the assembled crowds before the firing began. (Town of Sharpsburg.)

The centennial of the Civil War was observed from 1959 to 1965. It was during this time the activity of "Civil War reenacting" took off in popularity. Here, members of the 4th Maryland Artillery are ready for action at the Washington County fairgrounds with their gun and limber harnessed to a team of six mules. (Washington County Historical Society.)

Commemorating the war is an ongoing part of Washington County culture. In 1924, the families of the veterans of Reno Post No. 4 (a white post) erected a memorial to their veteran family members in Rose Hill Cemetery (right background), but no such memorial existed for Lyon Post (African American). On September 21, 2013, the City of Hagerstown dedicated a new monument to the men of Hagerstown's African American post of the Grand Army of the Republic, Lyon Post No. 31. On that day, Lt. Gov. Anthony Brown unveiled a much overdue tribute to Washington County's African American Civil War veterans. (Executive Office of the Governor of Maryland.)

DISCOVER THOUSANDS OF LOCAL HISTORY BOOKS FEATURING MILLIONS OF VINTAGE IMAGES

Arcadia Publishing, the leading local history publisher in the United States, is committed to making history accessible and meaningful through publishing books that celebrate and preserve the heritage of America's people and places.

Find more books like this at
www.arcadiapublishing.com

Search for your hometown history, your old stomping grounds, and even your favorite sports team.

Consistent with our mission to preserve history on a local level, this book was printed in South Carolina on American-made paper and manufactured entirely in the United States. Products carrying the accredited Forest Stewardship Council (FSC) label are printed on 100 percent FSC-certified paper.

MADE IN THE USA